SECRET ROMSEY

Ian Dickerson

AMBERLEY

First published 2018

Amberley Publishing
The Hill, Stroud
Gloucestershire, GL5 4EP

www.amberley-books.com

Copyright © Ian Dickerson, 2018

The right of Ian Dickerson to be identified as the
Author of this work has been asserted in accordance
with the Copyrights, Designs and Patents Act 1988.

ISBN 978 1 4456 7895 5 (print)
ISBN 978 1 4456 7896 2 (ebook)

British Library Cataloguing in Publication Data.
A catalogue record for this book is available from the
British Library.

Origination by Amberley Publishing.
Printed in Great Britain.

Contents

Introduction

Nestled between Winchester, Southampton and Salisbury and just 30 miles from the south coast town of Bournemouth, Romsey is a small town with a big history. Much of that is due to the proximity of the River Test, which connects Ashe, near Basingstoke, with Southampton by way of Romsey and has for centuries provided work, rest and play for people settled in the area.

Of course, given it's been around for well over a millennium, Romsey Abbey also plays a large part in the town's long history as well, whether as the main landowner in the area or as a simple place to worship, it's been a focal point of much of the life in the town.

But it's also down to the people. And perhaps that is the real secret of Romsey, for in researching this book it's clear that Romsey has always had a strong sense of community, whether it be the wealthy eighteenth-century landowners who made provisions in their wills to provide land and money to ensure the education of local children, the celebratory

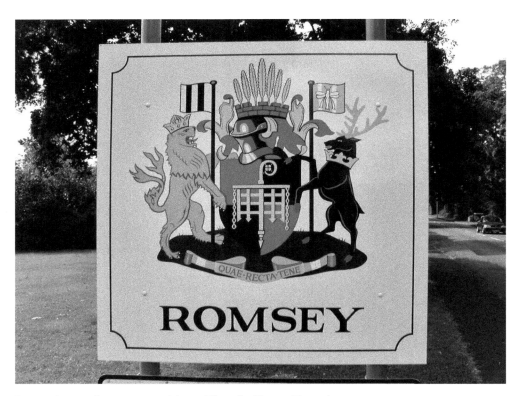

Romsey's coat of arms greets visitors. (Photo by Harvey Turner)

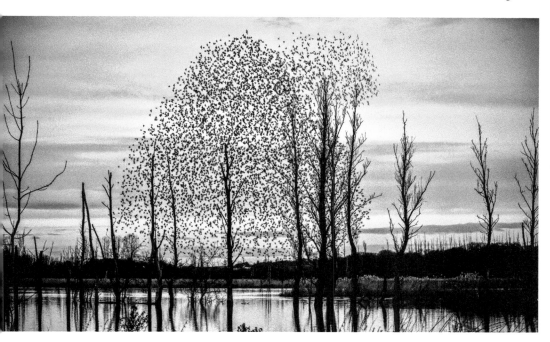

Starlings over Fishlake Meadows. (Photo by Natasha Weyers, Nature Embraced Photography)

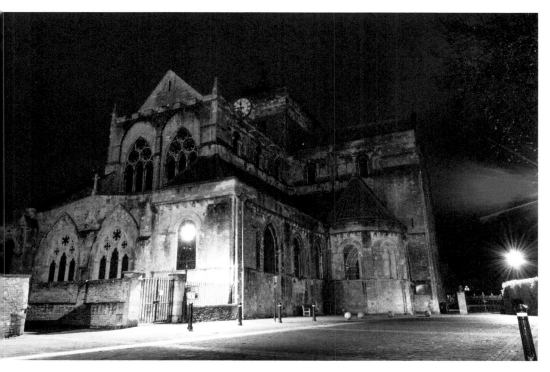

Romsey Abbey at night. (Photo by Nick Chivers)

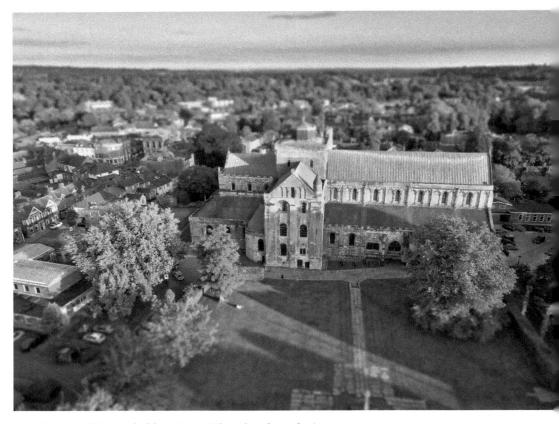

Romsey Abbey and Abbey Green. (Photo by Alex Baker)

street parties in the 1950s and '60s or the turnout for Earl Mountbatten's burial ceremony in 1979 when crowds were 'six deep on the roads'.

It's easy to be cynical in the twenty-first century and suggest that perhaps social media has eradicated the true sense of community, but you just need to look at the example of George, a fifteen-year-old from Romsey with Asperger's syndrome who wanted to distract himself from the stresses of his school exams by chopping kindling and selling it. His mother posted about it on social media and within a few days he had a couple of hundred orders to fill. So, sure, the traditional community spirit may have changed. No longer is the town based around one or two key employers who dominate the town in every sense; the world has moved on, and Romsey and the community around it has adapted.

According to *The Guardian*, 'There's something resoundingly, timelessly English about the place' and indeed there is, but Romsey is also a dynamic town, changing with the times. Perhaps not fast enough for some, but if it didn't it would surely stagnate and die. My family and I have lived in the area for almost twenty years and have seen it change, grow and evolve. We've seen shops and people come and go, we've seen royal visits, we've seen the town expand and the town's Victorian drains complain about it, we heard Elton John play at Broadlands (as, I suspect, did many people in the town) and above all we've

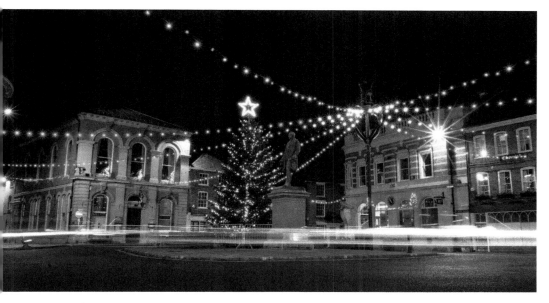

Romsey Market Place at Christmas. (Photo by Nick Chivers)

The Hundred really is the centre of the town. (Photo by Harvey Turner)

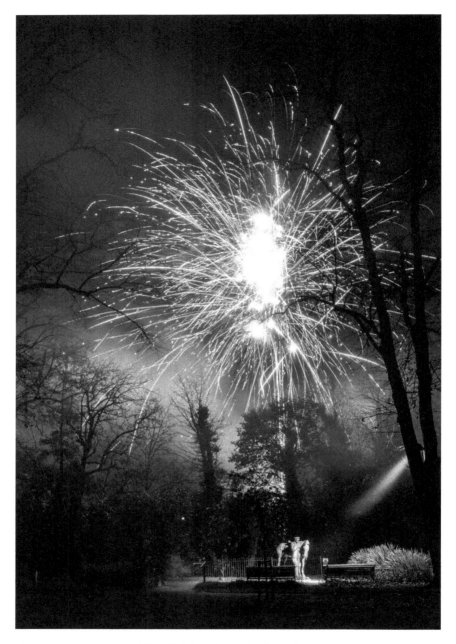

Fireworks over Romsey Memorial Park. (Photo by Nick Chivers)

seen the town go charging into the twenty-first century with all the problems, challenges and good things that entails.

In putting this book together I've discovered many things I never knew about Romsey, whether it be the visit of the last German emperor or the provenance of some of the road names in the area. I hope you too will enjoy discovering secret Romsey.

1. Secret Religion

Since the first Romsey Abbey was built in the tenth century it has dominated the town, whether as a central place of worship or, for the early part of its history, as a major landowner.

Its origins lie with Edward the Elder, son of Alfred the Great and King of the Anglo-Saxons from AD 899 to 924. He founded a nunnery in the area under the charge of his daughter Elflaeda and granted them large tracts of land – the town and land on the east of the river were mostly under the ownership of the abbess.

King Edgar the Peaceful, who sat on the throne from AD 959 to 975, is said to have regarded Romsey with special affection. He 'refounded' the abbey in 967 – believed necessary because the initial religious community in Romsey was quite small and when Elflaeda died it dissipated. On Christmas Day in 974 Edgar appointed Merewenna as its abbess. She was given charge of the queen's young stepdaughter Ethelflaeda and would become something of a foster mother to the young Princess. Ethelflaeda would later reputedly stand naked in the River Test in the middle of the night reciting religious chants for hours on end and go on to become abbess around the time of the first millennium.

After Merewenna died, Edgar gave the nuns the right to choose their own abbess as well as land in Erdington, near Salisbury, and other large woodland estates. In return the nuns handed over gifts including 'a finely wrought dish, armlets splendidly chased and a scabbard adorned with gold' valued at £112 10s. As the principal landowner in the area, the abbess was effectively the ruler of Romsey and she would, through her steward, deal with the day-to-day life of the town as well as most lawbreaking. A community grew around the abbey, but in 994 the abbey itself was destroyed by Sweyn Forkbeard and his Viking soldiers. It was rebuilt in the early twelfth century with the current structure, which was built on the same foundations.

Romsey Abbey and the town centre. (Photo by Alex Baker)

Romsey – always a place for the royals. (Photo by Nick Chivers)

At an entrance to Romsey Abbey. (Photo by Harvey Turner)

The abbey continued to grow until the Black Death arrived in 1349. It decimated the population of the country with a death rate thought to be as high as fifty per cent, and in the abbey seventy-two nuns died, leaving just nineteen to keep it going.

The abbey and the area struggled to recover. A second aisle was built on the north side of it to accommodate a parish church for the people of the town – dedicated to St Lawrence, the patron saint of librarians and comedians. It was screened off from the rest of the building and allowed people to come and go without impinging on the nuns' use of the abbey.

That north aisle was where those in charge would receive their tithes. The priest in charge would receive every tenth cow, calf and pig, though no one can shed any light on how they actually dealt with them. However, one day a rather pompous, tight-laced clergyman was called upon to christen a child, but on asking its name the mother who brought it said, 'I don't know, sir. It's your child!' 'My child?' exclaimed the priest. 'Yes, sir, it's the tenth child...' Records fail to show the outcome of that particular conversation.

Romsey's history is well signposted. (Photo by Harvey Turner)

This dual facility probably helped save the abbey when Henry VIII dissolved the monasteries in 1539. Unlike so many others, the actual building wasn't demolished, although the community was forcibly dispersed. Five years later the townspeople purchased the abbey from the Crown for the sum of £100. They later demolished the extra aisle as the abbey was too large for their needs and resources.

The abbey sustained further damage in 1643 during the English Civil War when, after defeating the Royalists in March of that year, William Waller's Parliamentarians plundered the town, pulling up seats in the abbey and destroying the organ while 'a zealous brother in the ministry' preached to them.

By the eighteenth century the abbey was in a very sorry state, with one visitor in 1742 noting that at least forty windows were bricked up.

By the nineteenth century Canon Gerard Noel and subsequently Revd Edward Lyon Berthon worked to restore the abbey to its former glory. 'The galleries were taken down, the ugly lath and plaster partitions removed. The great north transept and the chancel roves renewed (at a cost of £5 000) and the whole of the carved–oak work of the chancel and choir was done.'[1]

In the twentieth century the abbey remained a focal point for the town, with funerals, weddings and all manner of visitors becoming a regular feature. In 1907 Kaiser Wilhelm, the last German emperor and the eldest grandchild of Queen Victoria, spent three weeks in England on vacation and came to see the abbey, writing his name in the visitor's book. The Duke of Edinburgh and the then Princess Elizabeth (now Queen Elizabeth, of course)

[1] *The Guardian*, 8 November 1899.

A nineteenth-century publication available to visitors in the town.

The Restoration of Romsey Abbey was begun by the Rev. the Hon. Gerard Noel, 50 years ago, and has been slowly progressing ever since. The sum of £5000 is needed to complete the work and make it the most perfect specimen of Norman work among our Parish Churches. The reader of this Hand-book is invited to help by sending a donation however little, to the Restoration Fund, Capital & Counties' Bank, Romsey, Hampshire.

July, 1895.

Donations still welcome today.

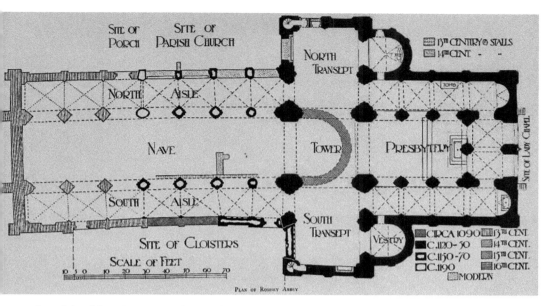

A plan of the abbey. (*A History of Hampshire and the Isle of Wight,* 1900)

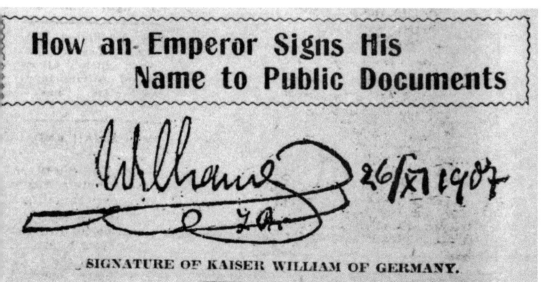

How an Emperor Signs His Name to Public Documents

SIGNATURE OF KAISER WILLIAM OF GERMANY.

In the ordinary course of the business of running his empire the German emperor signs a good many hundred documents every week. It is stated that in the three weeks he recently spent in England, when he was supposed to be taking a vacation for rest, he affixed his signature to state papers and letters no less than 1,000 times. This is a copy of his signature as inscribed in the visitors' book at Romsey Abbey.

The Kaiser left his mark in the abbey.

spent the first two weeks of their honeymoon at Broadlands and would attend services at the church. News reports of the time noted that more than 11,000 people jammed in to Romsey to see the couple (the day-to-day population was around 7,000 at the time) and that 'sight-seers would hoist themselves on tombstones in the churchyard, carried boxes, chairs and even step-ladders in the little cemetery. Some even hung from treetops to get a better view.' Those same news reports also noted that a number of hymn books had gone missing, their absence attributed to souvenir hunters.

DID YOU KNOW?
The early abbesses at the abbey were of royal or elevated birth and so highly celebrated for sanctity, leading the monastery of Romsey – from a very early period – to be considered one of the first establishments for the education and culture of the female mind.

Indeed, the Queen and Duke of Edinburgh's son, Prince Charles, also headed to Broadlands after his marriage, arriving with Princess Diana in late July 1981. Reports noted:

Yesterday the latest Royal honeymooners swept past a crowd of thirty thousand people, double Romsey's population, as a brief glimpse of pink ostrich feathers, discreet grey tailoring and graciously turned heads was visible ... Only twenty minutes before the couple were due five local men were spotted inside the gates of Broadlands, sitting on the grass. They were surrounded by police and turned out, but not charged.

Reports also noted some of the local celebrations:

Mr Clive Morgan, landlord of the Bishop Blaize Inn, got local artist Denzil Walker to paint a 8 ft high picture of St Paul's in front of his pub with two 8ft paintings of the Prince and Princess executed by sign-writer Barry Hobbs. Mr Morgan also stuck two knights in silver-coloured plastic armour, on the side of his pub. As a clincher he arranged a medieval *It's a Knockout* contest in which one of the teams was composed of local footballers dressed as nuns.

Perhaps the saddest event of recent times was the burial of Lord Mountbatten, a second cousin once removed of the Queen and an uncle of Prince Philip. Termed by many journalists as 'Romsey's grandfather', he'd done much for the town since he'd married Edwina Ashley, who'd inherited Broadlands from her father Lord Mount Temple in 1922. He and several members of his family were assassinated by an IRA bomb in August 1979. His funeral was held at Westminster Abbey in London and his body carried by train to Romsey for a private burial in the abbey. As *The Guardian* noted:

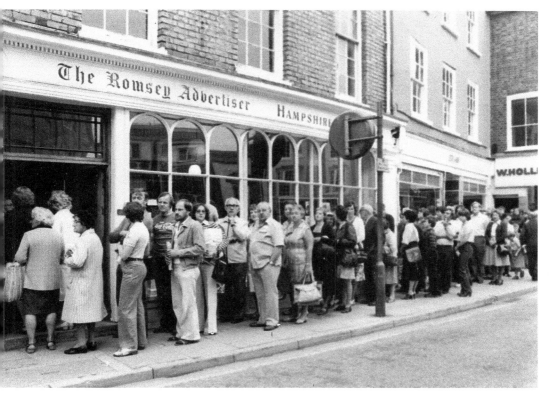

Queue to sign the book of condolence for Lord Mountbatten. (Courtesy of the Viney family collection)

> The shops ... did not open at all in his memory...so that shopkeepers could join those outside the private burial ceremony...At dawn there was a solitary police constable outside the Abbey ... By noon crowds were beginning to gather and by ten to three, when the Queen and the Royal Party arrived, they were six deep on the roads.

But weddings and funerals aside, the abbey has a vibrant and growing congregation and maintains its place as a significant focal point in the day-to-day life of the town. However, for the religiously inclined, Romsey offers a wide range of religions and has done so for many years.

Almost a literal stone's throw from the abbey is the United Reformed Church (URC), but it wasn't always known as that. The URC – the church, not the building – only came into being in 1972 when the Presbyterian Church of England merged with the Congregational Church. The URC in Romsey – the building, not the church – used to be a Congregationalist church and was built sometime around 1887 or the following year. It became a Grade II-listed building in December 1972. The URC has a sister church in Braishfield, a small village just outside of Romsey, which was founded in 1818.

The current Romsey Methodist Church is to be found roughly in the middle of The Hundred, the main commercial street in the town. Methodists have been worshipping in Romsey since 1811 when the Primitive Methodists had a chapel a short distance away

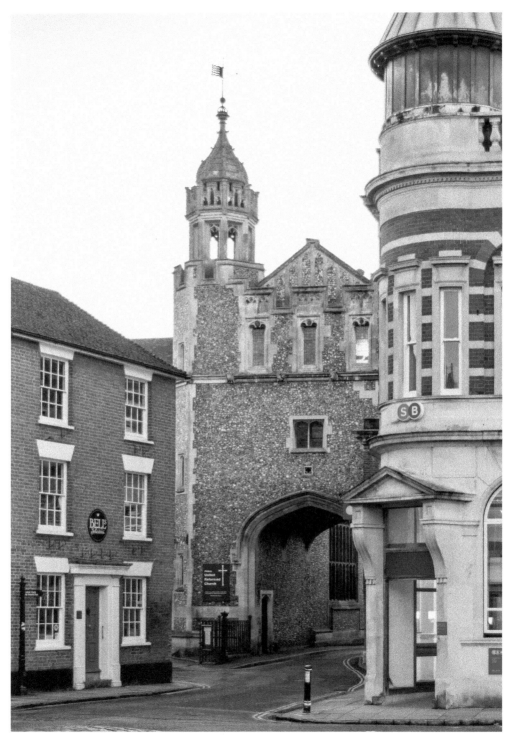

The abbey gateway and United Reformed Church. (Photo by Nick Chivers)

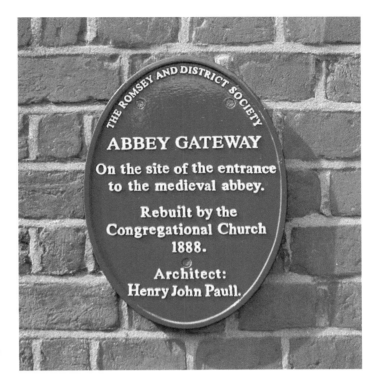

Right: Now the United Reformed Church. (Photo by Harvey Turner)

Below: United Reformed Church. (Photo by Harvey Turner)

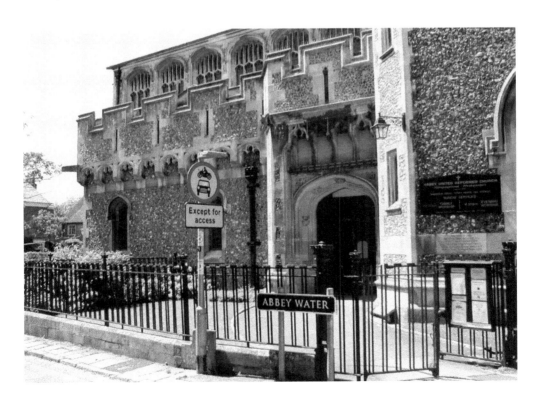

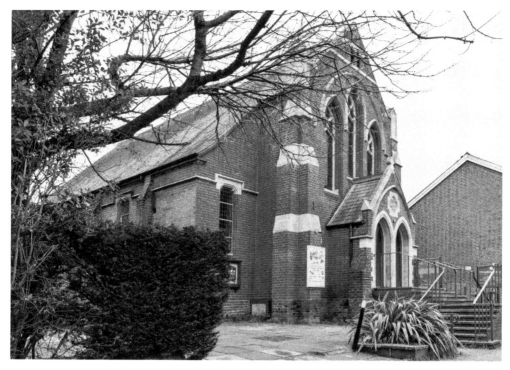

Methodist Church. (Photo by Nick Chivers)

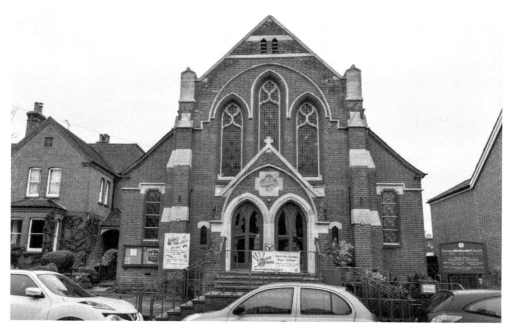

Methodist Church. (Photo by Nick Chivers)

St Joseph's Church. (Photo by Nick Chivers)

from the present church. The Wesleyans built a chapel in Banning Street in 1813, but by 1875 reports noted that 'the life of Methodism is being crushed out in the place' due to the sinful activities that were going on in Banning Street at the time and many Methodists refused to attend that chapel. The Primitive Methodists built a new chapel at the top of Middlebridge Street in 1895 and when the two united that chapel was taken on by the Elim Pentecostal Church. The present Methodist Church was opened on 31 May 1882 and 100 years later an extension was built on to the rear of the building to incorporate the increase in worshippers.

The history of St Joseph's Roman Catholic Church, which is to be found just a few minutes' walk from the abbey, is very much linked with the Sisters of La Sagesse, for the church actually sits in their grounds. The La Sagesse Sisters (also known as the Daughters of Wisdom) were founded in Brittany, France, in 1703 with aim of caring for the sick, the poor and the orphans as well as educating the young. Their founder, St Louis Marie de Montfort, also established a company of priests and brothers: the Montfort Missionaries. In the 1890s they opened a convent and the church in Romsey, and in May 1910 they opened Montfort College to more than sixty students. Montfort College closed in 1978 when it became the headquarters of a construction firm and was eventually converted into private apartments. The church and the convent, however, are still going strong.

A Quaker group was formed in Romsey in 1668 and a meeting house built in the town just over a century later. That was sold in 1795 and by the early nineteenth century Quakers

had all but disappeared from Romsey, leaving those interested to attend meetings at the Southampton Meeting House. But the Romsey Worshipping Group was resurrected in 2015 and now meets once a month at a site on Love Lane.

The current Romsey Baptist Church, situated roughly halfway down Bell Street, was built in 1811. It's since been extended several times – the hall was built in the 1920s, additional rooms added in 1972 and the size of the worship area increased in the early 1990s – and the church remains a focal point for the community.

In 1978, four people started meeting in a home in Romsey in the earliest days of Romsey Christian Fellowship, with a vision to do church differently! In addition to their Sunday gatherings they also formed a connection with a new church in Southampton called the Community Church, meeting with them in one of their Southampton midweek house groups. As their numbers increased Romsey based groups were started and the larger numbers led to Sunday meetings being held at the English Court building at the end of Alma Road.

By 1981 the church of around forty people was renamed New Life Church and as it continued to grow various meeting places were rented, including the Town Hall, Crosfield Hall and local schools.

For thirty years or so the church was led by Pastor Peter Light, who retired in 2013 when the current leader, Sim Dendy, took over. A name change to Freedom Church was then made in 2015 to reflect the mission of the church to bring freedom to as many people as possible, reflected in their close ties with Christians Against Poverty debt counselling work and the Romsey Foodbank, as well as their teaching on living lives of freedom in close relationship with Christ Jesus.

The church of 200 or so currently meets at the Romsey School in Priestlands on Sundays and in numerous homes around the area for midweek meetings. Although it has administrative offices these days, Freedom Church still does not yet have its own meeting place.

With all these different religious iterations in the town you might think there would be some competition among the different congregations, but the churches do a grand job of working together, with a website (churchestogetherinromsey.com) simply pointing out that 'our churches vary in size, style and location and we are confident that there will be one to suit you and your family'.

DID YOU KNOW?
Earl Waltheof was the last of the Anglo-Saxon earls and the only English aristocrat to be executed during the reign of William I. In the early twelfth century a tomb cult in his name was being promoted by the nuns at Romsey Abbey. The then Archbishop of Canterbury wrote to the Archdeacon of Winchester and the Abbess of Romsey ordering them to cease the cult or be suspended from divine office.

2. Secret War

Romsey is, by just about every definition, a small town. According to the 2011 census it had a population of almost 17,000, which, if you were to rank the UK's towns and cities by population, puts it way behind London's 8 million plus, but way ahead of the small town of Aghory in County Armagh, whose population back in 2011 was just fifty. Yet, for a small town, it gets involved in a lot, including war.

Mind you, it seems that everyone got involved in what's traditionally called the English Civil War, although there were in fact a number of different conflicts. Between 1642 and 1651 there were three different wars that pitted Parliamentarians (also known as Roundheads, and their goal was to give Parliament control over the day-to-day running of the country) against Royalists (also known as Cavaliers and who, unsurprisingly, given the name, supported the king's right to govern).

Romsey clearly appealed to both sides. By the end of 1643 the Royalists occupied the town, but soon enough the Parliamentarians arrived and seized control. The Royalists fled. The Parliamentarians went on to plunder the town, but by the end of 1644 the Royalists were back in control. In some ways they were no different; they plundered the town, leaving it in January 1645. Romsey would recover from this traumatic time in the country's history, but it took many years.

Many believe that one souvenir remains from that period. In the town centre, outside the current home of the Conservative Club, are the remnants of a wrought-iron sign. It

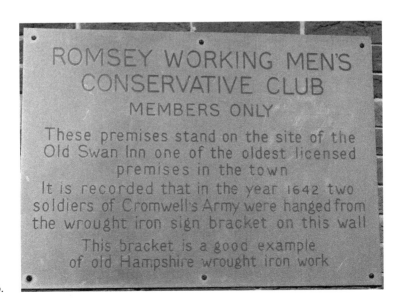

Greeting as you enter the Conservative Club.

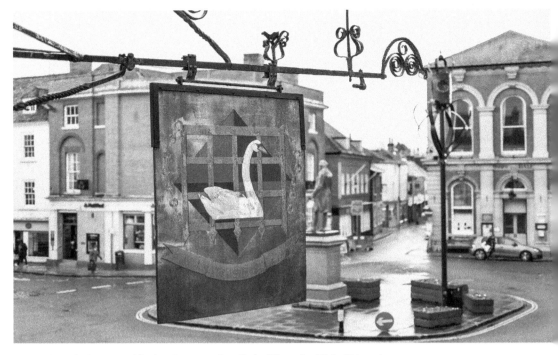

Wrought iron outside the Conservative Club. (Photo by Nick Chivers)

hangs over what used to be the site of the Old Swan Inn, where, in the early 1640s, Lord Fairfax, a general in the Parliamentarian army during the civil war, stayed there for a while.

Fairfax had a reputation as a no-nonsense disciplinarian and found the wrought-iron sign useful to hang deserters on. Indeed, given its length he discovered that he could hang two at a time, and some people believe that on one occasion one of the soldiers managed to free himself and escape down a nearby alley, where he died, leading to that alley and adjoining properties to be haunted by his ghost...

Over 200 years later, in 1887, the British Army centralised the purchase and training of horses and mules as remounts under the guise of the Army Remount Service. In November 1914, with war having broken out, they started construction of a new depot on Pauncefoot Hill in Romsey. It was completed in just over four months at a cost of £152 000, with the first horses arriving on 19 March 1915. The horses, many of them semi-wild from North and South America, would arrive at Romsey station and were led through town to the camp, causing inconvenience and danger to pedestrians. It was a minor inconvenience in the town centre, but when they got up towards Pauncefoot Hill they blocked the lanes around Ridge, stopping pupils from getting to Ridge School. As a result, many students transferred to Copythorne School; numbers dropped in Ridge and the school eventually closed in 1934. The camp, centred on Ranvilles Farm, was a 500-acre site and housed a complement of more than 2,000 men (the population of Romsey and nearby villages was estimated to be under 7,000 people at the time). It was partially self-sufficient, growing 40 acres of potatoes and selling old horseshoes, horsehair and manure.

Many of the horses would be sent on to Swaythling in Southampton to be shipped to France. During the First World War around 110,000 of the 1.3 million horses and mules involved in the conflict passed through the depot. The camp was closed in April 1918 and 480 huts and sixty-nine horse shelters were later sold at auction with hard core from the site being used to help build the Romsey Memorial Park.

In 2015 Princess Anne unveiled a life-sized bronze resin statue of a warhorse in the local Memorial Park in tribute to those horses that died in the First World War.

In 1916, a British Army camp was established at Woodley, but this was taken over the following year by the US Army, who used it as a rest camp and built more substantial accommodation of timber and brick. Some of the American troops recorded their visits to the town:

> Romsey is an interesting little place. Many hundreds of years ago it was a rest camp for the Roman soldiers when they invaded England ... Trees, hedges and sweet scented flowers abounded everywhere. Spring was just opening up and it seemed as if we were in the second Garden of Eden.[2]
>
> Woodley is a memory to most of them now, a memory of cold baths, of strange little out-of-the-way forbidden inns, or marmalade and cheese and tea, and of a YMCA that sold strawberries, of nights when the faint rumble of guns warned away German air-raids over the cities. There the men had English rations. The English and American soldiers do not live happily on the same food or amount of food.[3]
>
> While we hiked through the little town I got a chance to see my first English village. Everything in Europe is built to stay. So it is in this little town. The houses are mostly all built of red brick and each house has a name. Every house has a pretty little flower garden out in front and the knockers on the door and the nameplates are polished until you can see yourself in them. Then past the little town we came upon the old houses set way back among the trees with the curling road leading up to them. In fact the shrubbery leading up to them was so thick that unless you went inside the fence you could not see the houses.[4]
>
> It was hard to understand the English people, almost as hard as it was the French later. The towns are nothing like in America, especially the stores. In small places they are dwelling houses, with one small room used as the salesroom.[5]

DID YOU KNOW?
During the Second World War troops suffering from pneumonia were cared for in the Town Hall, lying on the floor with just one blanket each.

[2] War diary by C. M. Hammond.

[3] *Lincoln Star*, 29 June 1919.

[4] Corporal Arthur J. Jones, December 1918.

[5] *The Pretty Prairie Times*, 9 January 1919.

Commemorative stone in Memorial Park. (Photo by Harvey Turner)

After the war the camp was demolished, but during the Second World War some of the land at nearby Ganger Farm was used to establish a Prisoner of War camp. This camp, known as Ganger Camp, was populated initially with Italian POWs who were repatriated fairly quickly once the war was over. They were replaced by German POWs, with the last of them leaving in 1947. After the war it was used as temporary housing by the council, but in 1958 they started replacing the huts with new houses and the area was christened Woodley Close.

For some time before the First World War local people had demanded a public park, but this had been dismissed by the town council as too expensive and unnecessary. At the end of the war, however, a discussion was had on how to honour the dead and a memorial park was deemed appropriate. The park opened in 1921 and contained a memorial to those who had fallen in the war, designed by two local men: C. W. P. Dyson and S. C. Greenwood. The park also contains a Japanese artillery gun from the Second World War – one of a pair that were captured by the British and brought back to Romsey by Lord Mountbatten; he donated one to the town and kept the other on the grounds of Broadlands.

During the Second World War the US Army also maintained a supply base in Lockerley, around 5 miles out of the town and near enough for their troops to make the most of the town's facilities. After the war, in August 1948, all the surplus stores were auctioned off, including '30 tones new electric cable, 4 tons cadmium and enamelled copper electric wire, 6 000 headgear receivers, 300 telephone loudspeakers and 9500 battery handlamps'.

Other camps in the area were marshalling camps in preparation for D-Day. Camp C14 was based at South Holmes Copse, to the east of Romsey between Crampmoor and

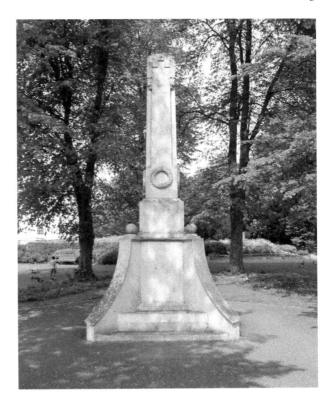

Right: The war memorial in the Memorial Park. (Photo by Harvey Turner)

Below: Second World War artillery gun in Memorial Park. (Photo by Nick Chivers)

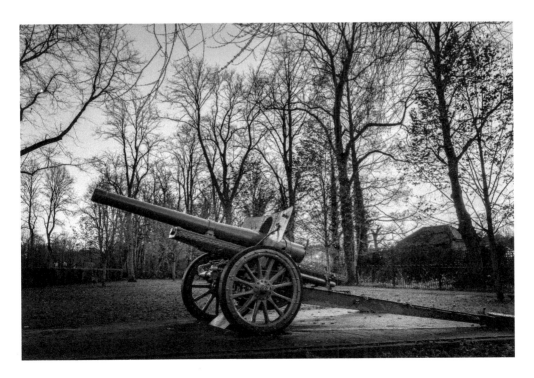

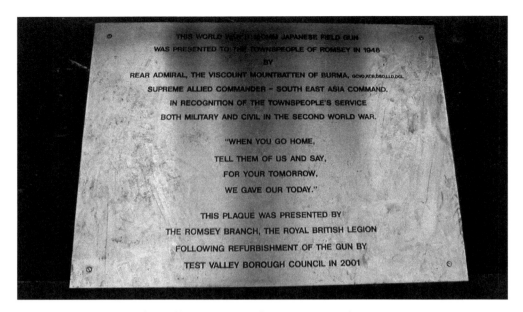

Plaque commemorating the artillery gun. (Photo by Harvey Turner)

Ampfield. This camp had a capacity of 2,750 personnel and 400 vehicles. Camp C15 was based at Broadlands with a capacity of 1,250 personnel and 180 vehicles, while camps C16 and C17 were in Nightingale Woods, on the outskirts of Romsey near Toothill had a total capacity of 3,250 men and 465 vehicles. At the end of May 1944 the camps were sealed and the troops inside were not allowed to leave. This was to minimise the risk that spies, or indeed the British public, might realise that D-Day was near.

Not only were troops camped at Broadlands but the house itself was used as an annexe to the Royal South Hants Hospital with Lady Mountbatten, a leading member of the St John's Ambulance, taking a personal interest in the patients who were looked after there. Additionally, as D-Day approached, Lee House on the estate was used as a planning centre.

DID YOU KNOW?
During the winter of 1626–27, 210 soldiers were billeted in Romsey for fourteen weeks at a cost of £178. Another company of ninety were billeted there in April.

3. Secret – and not so secret – Food and Drink

At one time there were more than eighty public houses in the town and surrounding area and by the time of the 1911 census, which recorded a population of 4,669 in the area, there was one pub for every 151.5 people and thirty-eight in the town centre alone – more than twice the national average.

That's not to say that the people of Romsey had a drink problem. Historically the town has been on some important routes, whether it be to go from Winchester to the west of England or from the wool-producing areas of Wiltshire to Southampton. Even now, in these troubled times for landlords, the proximity of motorways such as the M3 and the M27 helps provide passing trade.

Part of the reason for those remarkable statistics from 1911 was that just over fifty years earlier Romsey had become a brewing town. In 1858, Thomas Strong, a twenty-eight-year-old from London, who'd followed his father Samuel and grandfather George into the brewing industry, leased the Horsefair Brewery along with twenty-two licenced houses from the widow of Charles Hall, who'd previously owned and operated the business.

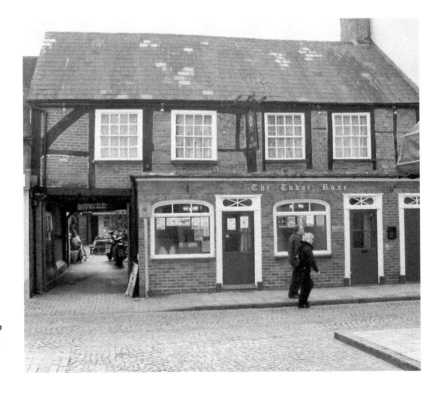

The Tudor Rose pub in the Market Place. (Photo by Harvey Turner)

The Bricklayer Arms. (Courtesy of the Viney family collection)

The Horsefair in the centre of Romsey. (Photo by Nick Chivers)

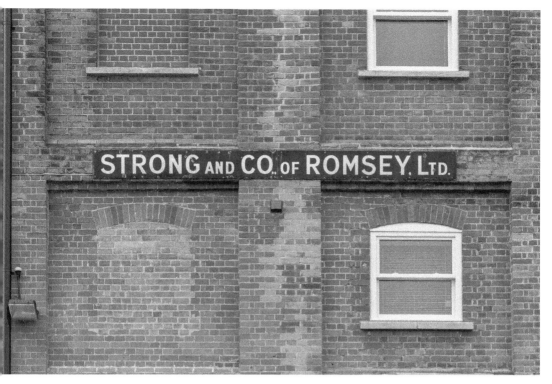

Evidence of Romsey's past survives. (Photo by Nick Chivers)

Strong built himself a new home, Harefield House at the top of Winchester Hill, around 1880. Sadly though, just a few years later, in 1886, he committed suicide.

The business was sold and that same year when David Faber bought it he found it in rather a sorry state, with production down to 3,000 barrels a year and the number of licensed houses down to fourteen. But John David Beverley Faber, to quote his full name, saw an opportunity; population was growing rapidly and industry was developing.

At the same time as he bought the Horsefair Brewery he also acquired two local competitors, George's Brewery in Bell Street and Cressey's Brewery in The Hundred, but kept the Strong's name. By the time he died, in 1931, as chairman of the group, he controlled breweries in Hampshire and neighbouring counties with over 500 pubs tied to them.

They were a major employer in the town for over a hundred years, but as is often the way of these things, the company was taken over by Whitbread in 1969 and within a decade brewing had ceased in the town.

A few decades later, in 2010 to be precise, brewing was revived in the area by the Flack Manor Brewery. Established by a trio of experienced brewers, they're based on the Greatbridge Road Industrial Estate and use traditional methods and locally sourced ingredients to produce a range of beers.

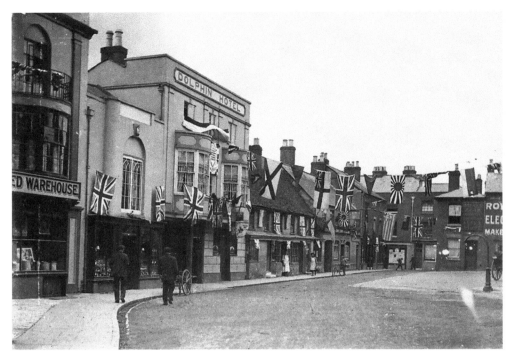

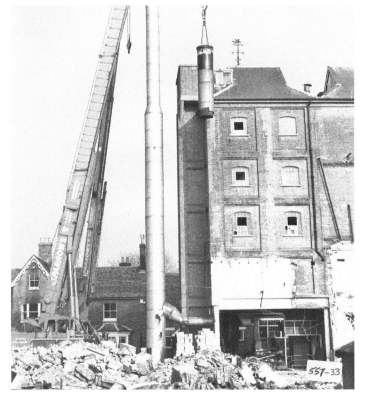

Above: The Dolphin Hotel, now sadly long closed. (Courtesy of the Viney family collection)

Left: Demolition of the second brewery chimney. (Courtesy of the Viney family collection)

DID YOU KNOW?
Brodie & Dowding of Salisbury produced Collins's Cordial Cephalic Snuff, which 'dispels the common head-ache and is of singular utility in case of deafness; removes stoppages of the head, dimness of the eyes, giddiness and drowsiness, and revives the spirits'. On 30 May 1826, they were authorised to state that a 'Lady from Romsey was perfectly cured of deafness by taking it: this lady found immediate benefit on commencing its use and particularly recommends it should be taken at bed time.'

Where There's Drink There's Probably Food

Part of the main commercial heart of the town is the Cornmarket. As the name suggests this was where local farmers traded their grain. In the mid-1800s pricing from Romsey market was regularly listed in the financial pages of *The Observer* newspaper, where you could find the price of wheat, barley, oats, beans and peas (40 to 43 shillings per quarter for the latter, in case you were interested).

Standing in the Cornmarket is a large, symmetrical two-storey building with three exposed fronts known, somewhat unsurprisingly, as the Old Corn Exchange. It is a Grade II-listed building and was built in 1864. It's had a variety of uses, aside from the obvious one: in the early 1900s it was operating as the Corn Exchange Cinema; it's been the headquarters of the Romsey Volunteers (much like the Territorial Army); and the cellars were at one time used as a store by a local brewer. It's currently occupied by Barclays Bank, who've been on site since 1994, with a property development company moving into the first floor at the time of writing.

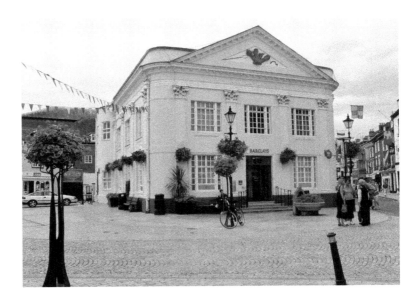

The Cornmarket.
(Photo by Harvey
Turner)

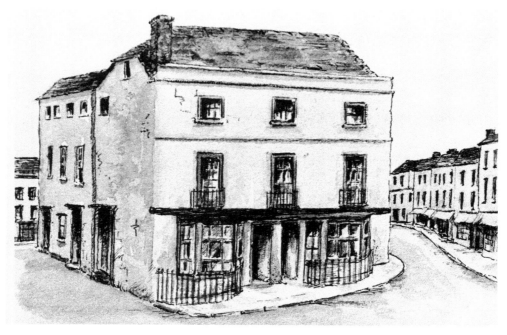

The site of the Corn Exchange in 1850. (Courtesy of Stratland Estates)

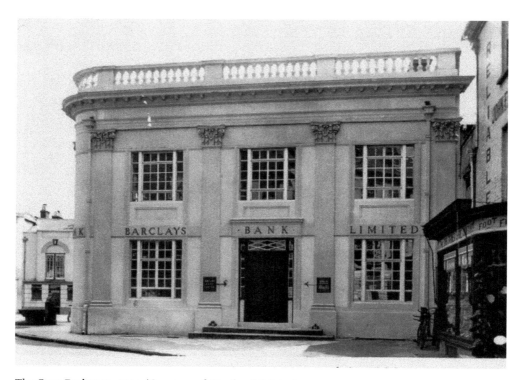

The Corn Exchange, 1930. (Courtesy of Stratland Estates)

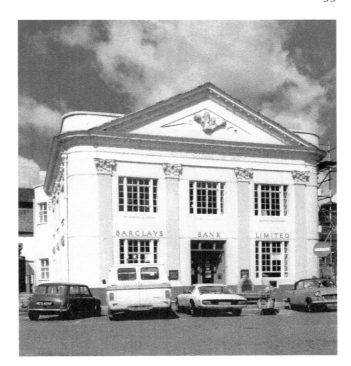

Right: The Corn Exchange, 1974. (Courtesy of Stratland Estates)

Below: The Corn Exchange, date unknown. (Courtesy of Stratland Estates)

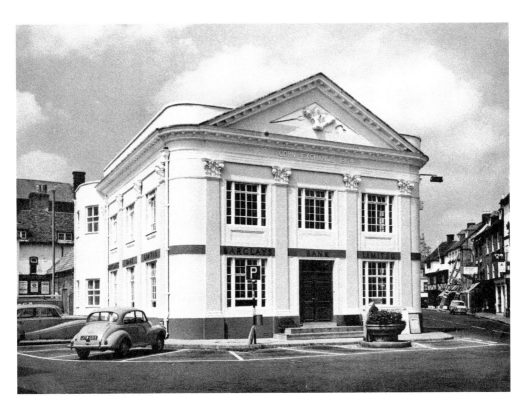

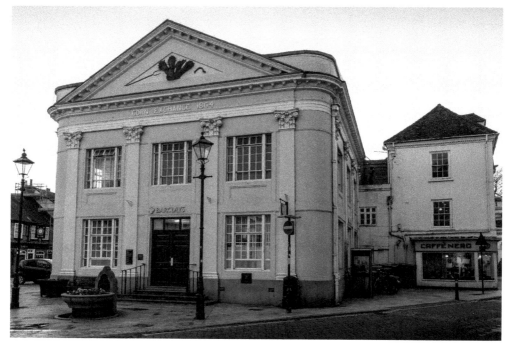

The Corn Exchange today. (Photo by Nick Chivers)

The Cornmarket is still used as a marketplace. Every Tuesday, Friday and Saturday you can find a wide range of stalls, but be warned, the wheat, barley, oats and beans have been replaced by much better-tasting bread, cheese, olives and fruit.

DID YOU KNOW?
In 1835, a labourer in the town was asked whether the quarter acre of land he occupied was of any use to him. He replied that he paid his rent regularly every quarter, had supplied his whole family – and the press were keen to note it wasn't a small one – with vegetables and had cleared 55s during the year, all this without infringing upon his ordinary working hours.

For almost 100 years Romsey was known around the world for its jams. The Hampshire Preserving Company, known locally as the jam factory, was based in a Tudor-style building in the town centre and was, at one time, one of the town's biggest employers, generating a pleasant smell of warm strawberries around the town. Dead or alive, the factory offered a reward of 6d for every queen wasp delivered to the factory gate throughout the soft fruit season.

Can label for Romsey Vegetables.

Coachbuilders in Latimer Street. (Courtesy of the Viney family collection)

The Hampshire Preserving Company started life in the mid-nineteenth century thanks to George Harris and his family, successful grocers who ran two shops in the town – one in Bell Street and one in The Hundred. Local legend suggests that his wife was making jam one year and found she had plenty left over, which was quickly sold in the family shops. The next year she purposely made plenty more to meet demand.

To keep pace with demand they soon moved into the old Tudor-style buildings, which had been occupied by a coachbuilder and was conveniently located opposite their home. When George Harris died the company was taken over by his sons, until the early

ONCE TASTED *they're asked for again!*

Open a can of English Grown "Romsey" Red Plums and you'll see why the discriminating housewife buys them. These delicious plums are a family treat, superior in every way to foreign produce. They are the choicest fruit ever placed on any table. *Ready sweetened*—just serve them with custard or cream and everyone will want a second helping. YOUR GROCER HAS THEM!

Choice
ROMSEY
Dessert Fruit
SWEETENED READY FOR TABLE USE
DELICIOUS WITH CUSTARD
RED PLUMS
SELECT IN HEAVY SYRUP
Preserved in HAMPSHIRE PRESERVING CO. *England by*

You have the choice of the following :—

Victoria Plums	Golden Plums	
Strawberries	Raspberries	Red Plums
Loganberries	Black Currants	Gooseberries
Morello Cherries	Kent Cherries	

Romsey DESSERT FRUITS

also unsweetened Bottled Fruits and the delicious "Romsey" Preserves. THE HAMPSHIRE PRESERVING CO., ROMSEY, HANTS. Fruit Bottlers and Jam Preservers for nearly half a century.

NATIONAL MARK
Regd. Trade Mark

Packed as fresh as they're picked!

Newspaper advert for more Romsey food.

twentieth century when it was sold to George Hattat. He continued to grow the business, adding marmalade and mincemeat to the product range as well as pickles and pickled onions. In the late 1920s they started canning fruit and vegetables on the site as well.

The jam was sold all over the south of the country, including Somerset, Dorset, Wiltshire, the Isle of Wight, Sussex and – of course – Hampshire. They also had a substantial export business, taking the Romsey name to Ceylon, South Africa, New Zealand and many other places.

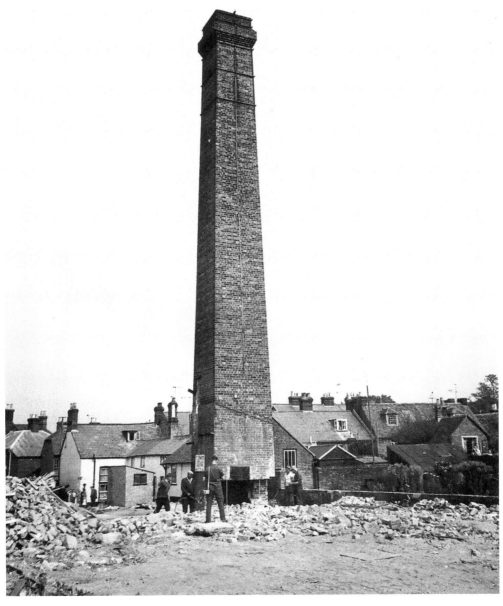

The jam factory chimney. (Courtesy of the Viney family collection)

The Market Place from Lord Palmerston's statue. (Photo by Harvey Turner)

The Town Hall and other buildings from the statue. (Photo by Harvey Turner)

George Hattat died in 1939 and was succeeded by his eldest son, but after the war the market dwindled as jam and bread for tea was replaced by cooked meals. The company had outmoded machinery and increasingly tight profit margins and closed in 1960. The site was then used as storage for classic cars until it was destroyed by fire in July 1964. For many years the new building on the site was occupied by the Waitrose supermarket, but that has now decamped to a purpose built site just off Alma Road, leaving the building to be occupied by an Aldi supermarket.

Alongside the jam factory was the tomato factory, or the less colloquial Wills Nursery. Arthur Wills moved to the area after the First World War and was looking to start up on his own. He identified some land on Botley Road near the railway and in 1925 bought 29 acres of land from the then owner Lord Mount Temple. Construction started in 1926 and he also built a railway siding to meet the need for bulk transit. As the depression hit in the late 1920s he started to struggle financially so built twenty-four houses in Tadburn Road, which were for sale or rent. The nursery closed in the early 1980s and houses have subsequently been built on the land.

In the twenty-first century there are monthly farmer's markets where local producers sell their food and drink. There is also an annual food festival, held in late summer, where they close off The Hundred and host over seventy stalls full of local fare.

DID YOU KNOW?
In 1934, the phone number for Strong & Co. was Romsey 2, which just begs the question of who was Romsey 1? Estate agents Woolley & Wallis were Romsey 129.

4. Secret Community

The dictionary defines community as 'a social group of any size whose members reside in a specific locality, share government and often have a common cultural or historical heritage', but that seems like a rather sterile and reactive definition. Romsey's population of around 17,000 reside in a specific locality and share a government, and, yes, they share the heritage of the town, but it doesn't necessarily mean they are a community or people feel part of the community. Over the years Romsey has had an enthusiastic, giving population who've been known to chip in to help other people when help is needed. That's more of a community.

Makaton

One of the most interesting and recent developments within the town is the drive to make it the first Makaton-friendly town. Makaton is, as the Oxford English Dictionary tells us, 'a proprietary name for a language programme integrating speech, manual signs

Worzel Gummidges and the marvellous Romsey Old Cadets. (Courtesy of Romsey Old Cadets)

and graphic symbols, developed to help those for whom communication is very difficult, especially those with learning disabilities.'

Hannah Anderson, formerly of Speaking Space, a day service for adults with learning difficulties and autism where they specialise in communication and independent skills, began the drive to improve the take up of Makaton. The Makaton Charity set her the objective that if she could get thirty organisations within the town Makaton friendly, then the town could declare itself the first Makaton-friendly town.

She approached the Chamber of Commerce, emergency services, library, the mayor and the town council to present the idea to them. They were enthusiastic and offered their support. She ran numerous talks and training sessions throughout the following year, keeping the profile and enthusiasm high. Nearly a year after launching the initiative she met her target: thirty organisations were Makaton friendly and Romsey was declared the first Makaton-friendly town.

Speaking Space regularly go in to Romsey to practice communication skills and support the local businesses to practice their signing. Local colleges have started bringing their users into the town to experience the Makaton-friendly environment. The results speak for themselves, according to Hannah:

> We now take our service users out regularly into the community and get them to order their drinks independently at the local cafes using Makaton signs, communication books and communication aids. A gentleman in his 30s who attends the day service ordered his very own hot chocolate for the first time in thirty years! It has made a huge difference in the confidence of those who use it to communicate to the point where they are running in to the day service eager to begin the day and get out in to the community. It has boosted their confidence, built stronger friendships and built a community presence of Makaton. It's become the talk of the town and brought the community even closer.

Oasis Christian Centre

There is an oasis in the heart of Romsey: Oasis Christian Centre, to be exact. The story behind it is one of community support and success, which is especially notable in these highly commercial times.

Early in 1984 a Romsey couple wanted to set up a shop that would sell Christian products as well as products from developing countries. They joined together with two other families and managed to raise the finance to buy the freehold of a shop in Church Street, next to the post office. But the building was showing its age – the deeds went back to 1642 – and was in a rather sorry state of repair needing a lot of work before the business could open its doors. By the end of September that year the work had been completed on the ground floor and the shop opened for business, while work continued on the two upper floors and roof.

The founders established a trust to safeguard the future of the shop in 1986 and in the paperwork set out their vision: 'acting as a focal point for Christians, for encouragement and the building up of God's people in the Christian faith in Romsey and worldwide... promoting, assisting, supporting Christian outreach work and charitable organisations for the promotion of Christian missionary evangelistic and relief works.'

Once the initial loans that were used to establish the shop had been repaid, in keeping with their vision, all surplus funds were donated to missionary and relief causes. In recent years the shop has turned over in the region of £150,000 per annum.

It's not just a shop, though, it's a focal point for charitable collections including Operation Christmas Child, the Food Bank, and Christian Aid donations. Over the years the performance of the team has been recognised through merit awards from the local Chamber of Commerce and the Christian Booksellers Association.

The Boys' Brigade

The Boys' Brigade is an interdenominational Christian youth organisation that was founded in Glasgow in 1883. In late 1964 ex-navy man Roger Bellis and a couple of other chaps started a Boys' Brigade company in Romsey, based at the Baptist Church.

Around the same time Hampshire County Council negotiated a lease with the Crown Estates to use the site of RAF Calshot, roughly half an hour away from Romsey on the Solent coast, as an activities centre. Their first course – sailing for Hampshire children – happened in May 1964.

Romsey Boys' Brigade in the 1960s. (Courtesy of Roger Bellis and Tom Viney)

Winchester Road, early 1960s. (Courtesy of the Viney family collection)

In 1965, Romsey Boys' Brigade enjoyed some weekend courses at Calshot including canoeing and dinghy sailing for beginners. There was a growing interest in sailing and the Romsey Brigade purchased a Portchester Duck dinghy for the sum of £25, giving access to more frequent sailing at Calshot. The Bellis family carried out all the repairs and maintenance.

The Romsey Boys' Brigade continued their activities at Calshot, gaining experience and a number of Duke of Edinburgh awards. While there, Roger Bellis met Edwin Gifford, a traditional sail enthusiast who had designed and built a boat on the lines of the Cape Ann, USA, cod fishing dories. Roger was looking to upgrade the Brigade's sailing capacity and was considering a whaler, both a pulling boat that is driven by oars and a sailing boat. But such a whaler would weigh around 1 and a half tonnes, whereas a dory such as designed by Edwin Gifford would only weigh half a ton. Gifford offered to give him the plans from his boat and to put him in touch with contacts and suppliers.

It was a lovely idea, but also very expensive. Roger's family offered to pay half of the costs for shared use of the boat. Building the boat provided Duke of Edinburgh Award work for the boys assisted by their fathers and the Bellis family.

Building a boat is no small commitment and, apart from anything else, requires a lot of space. At the time the Budds Lane industrial estate on the outskirts of the town centre was under construction and the basic hull of the boat was put together in a warehouse on the site. After that, a local farmer lent his hay lorry to move the finished hull to the Bellis' front garden. At the time they lived in Newtown, a small hamlet between Awbridge and Lockerley, just outside of Romsey, and all the lads from the pub opposite (The Bush Inn)

turned out to lift the hull of the boat over the garden wall onto trestles where work would continue.

The boat was christened *Golden Goose* and launch in May 1970. After around three years of sailing with the Boys' Brigade, with interest beginning to wane and the original project members and enthusiasts having moved on, the boat was sold.

RAODS

The Romsey Amateur Operatic and Dramatic Society (RAODS) was founded on 11 October 1934 with its early productions being almost exclusively Gilbert & Sullivan creations. The first show was a production of *The Mikado* at the Town Hall and a certain John Joseph Crosfield was in the audience for it. When he came to build the Crosfield Hall it was partly with RAODS in mind and they did indeed subsequently move there.

For thirty years or so they staged a pantomime and two plays every year, but with the move to the Plaza they have increased the number of shows. Notable productions have included a stage version of *The Hitchhiker's Guide to the Galaxy* in 1990. Seven years later, during a performance of *The Mikado,* singer Ivan Cotter suffered a heart attack on stage, which resulted in a triple-bypass operation.

Because they own and manage their own building, RAODS are different to most amateur groups in terms of responsibility and opportunity, and year after year they are determined to make the best of it.

Romsey Town Hall. (Photo by Nick Chivers)

The Beggars Fair

Every year, on the second Saturday in July, when hopefully the weather will play along, the Beggars Fair is held on the streets and in the pubs of Romsey. It's been running since July 1993 and was set up with the aim of showcasing local talent in a friendly, welcoming environment. Run by volunteers, one of the original goals of the first organising committee was 'to create a new tradition for Romsey, involving musicians, dancers, entertainers and above all audience'. It is now in its twenty-sixth year, so it's fair to say that has been achieved.

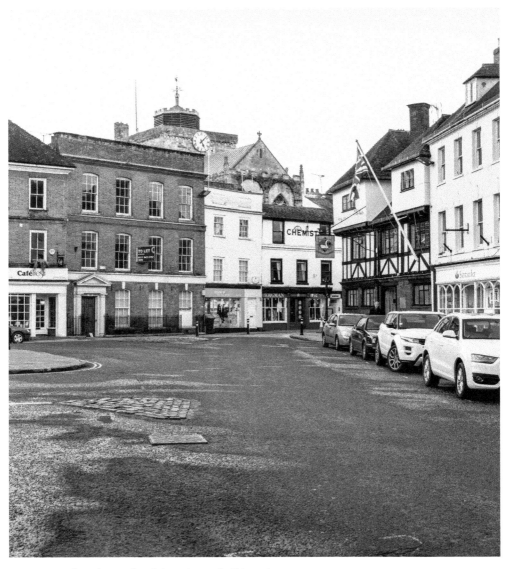

Romsey Market Place today. (Photo by Nick Chivers)

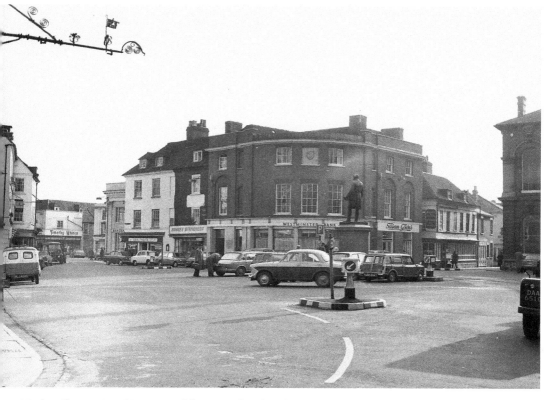

Market Place, 1960s. (Courtesy of the Viney family collection)

Local Schools

Education in Romsey has always owed plenty to religion and the community. The Red Cap Boys' School was founded by John St Barbe, a wealthy landowner, in 1658. Something of a philanthropist, he donated sufficient property to endow a school for poor but respectable boys, where they should be educated and clothed – but not fed – from the age of six to fourteen years. At age fourteen each boy was entitled to £25 for use by the parent, to be given to some master mechanic as a bonus. The boy was then apprenticed for seven years, receiving small wages that increased each year, according to the agreement in the indenture. The master or 'boss' had almost as much power over the apprentice's conduct as the parent until the indentures were cancelled. Their clothing consisted of a skull cap with a red tassle and band, a blue woollen vest and a closely buttoned coat, clergyman's bands around the neck, buckskin breeches, blue worsted stockings and low shoes.

In time this school was incorporated with the Romsey Boys' National School, which was built in Middlebridge Street in the 1830s. It was an Anglican-based free public school with free textbooks, which had an attendance somewhere between 150 and 200.

In 1872 a new Boys' National School was built on the corner of Station Road and Duttons Road. The building itself, now the public library, was been commissioned by

William Cowper-Temple (Lord Palmerston's heir) and designed by Eden Nesfield as a memorial to William's mother.

In the interests of balance it should be noted, so we shall do so here, that the Girls' National School, which was opened around the same time, was sited in Church Lane and is now known as Romsey Abbey School.

Government papers relating to education in 1835 contain an interesting count of schools in the area at the time. They note that Romsey Extra, the villages and area outside of the main town centre, contained:

- One infant school, which had been established in 1833, and contained twenty-eight children of both sexes.
- Nine daily schools. One was kept by Revd John Terwey and contained around twenty boys; one by the Baptist minister N. T. Burnett contained eleven children of both sexes; another had ten girls in; a bigger one had twenty-four pupils of each sex; and the other five collectively contained forty-eight boys and fifty girls.
- One Sunday school, which was supported by annual collections and monthly contributions of one half-penny from each child and was attended by thirty boys and twenty girls.

Romsey Infra, the main town centre area, had:

- Eleven infant schools, which had sixty-five boys and forty-three girls.
- Eleven daily schools, which included:
 o Nowes's Charity School, which was founded in 1718 and endowed with funds for educating, clothing and apprenticing twenty boys.
 o Another, established in 1723, had ten boys. This was merged in 1823 with the Boys' National School, which had an additional 120 boys.
 o One school founded by Lady Palmerston and supported by her family after her death had 132 girls.
 o Of the other eight schools four contained 107 boys, two contained twenty five girls, and two contained ten boys and eighteen girls.

There were additionally six Sunday schools supported by voluntary contributions. In two of these there were 220 boys and 198 girls. Two others had 106 boys and ninety-four girls, and two Baptist schools contained twenty boys and fifteen girls.

A British school was established by the Nonconformist movement as a non-denominational school, which was built on The Hundred in 1864 and designed by Parthenope, the sister of Florence Nightingale, whose family had helped finance the School. Just a few years after it opened it the buildings were extended and it continued as a school – latterly as the Romsey County Infants School until 1974 when it was converted into private housing.

In the twenty-first century, when the local schools are full to bursting, while the number of schools may have dropped significantly as the pupil count has increased, they remain community hubs, providing not just valuable education but sports facilities, community events, drama and music.

5. Secret People

For a town with such a long history it comes as no surprise to discover that Romsey has had its share of high-profile inhabitants and visitors. While this chapter makes plentiful mention of them, it's worth starting with a very low-profile name, one you almost certainly won't recognise, but one that made it into the national press in 1938.

In May that year – 1938 – Arthur Gregory of Shirley in Southampton was summoned to court, charged with exceeding the 5-mile an hour speed limit with a 12-ton steam engine at Michelmersh.

> Evidence was given by the police officers who passed Gregory on their bicycles. They alleged that the locomotive, drawing two trailers, travelled at a speed of about twelve miles an hour. They had to pedal very fast to overtake it. When they stopped the driver he exclaimed 'The old thing won't do it, the wheels would fall off'.

Eighty years later and, thankfully, most vehicles go a tad faster than that through Michelmersh.

It's worth mentioning John Reynolds Beddome here, for his was Mayor of Romsey eight times – 1829, 1835, 1836 (which he shared with Joseph May), 1842, 1851, 1856, 1857 and 1858, since you were going to ask, weren't you?! Beddome was a surgeon who was respected for his professional talent but also for his great benevolence and kindness to the poor and for promoting the interests of religion and humanity. He lived in Abbotsford House near the abbey and retired from medicine in 1859, after half a century of practice. He was also the physician to Lord Palmerston.

Another local notable was Ann Arter, who died in December 1830 and whose inquest was held at The Three Tuns public house.

> It appears that the deceased had dropped an old kettle into a stream adjacent to her dwelling, on which she hastened through Broadland's Lodge Gate and, in endeavouring to get it out, she went too far into the water and was carried a considerable distance before the circumstance was known. Press reports went on to note the verdict of accidental death. Then they added a bit of colour; 'The deceased, whose external appearance, except on Sundays, was almost beggarly, was possessed of considerable property, part of which had been amassed by collecting dung on the high roads, and frequently depriving herself of common necessities. On Sundays, however, her appearance was different, generally wearing a silk dress of an antique pattern with flounces and ruffles to correspond.[6]

[6] Quote from the *Hampshire Advertiser*, 11 December 1830.

Tales of Romsey's characters were told far and wide. In June 1939, many American newspapers told of Mrs Jane Hatcher, who had just turned 101 and was quoted as saying 'I make no secret about the reason of my longevity. I have always worked and lived hard and minded my own business.' They went on to note: 'Mrs Hatcher brought up a family of twelve on her husband's wages of $5 a week and has outlived her husband and seven of her children, her husband by thirty years.' In 1939, $5 equates to just under $90s at the time of writing, or just under £70.

Another lady of a certain vintage had made the press a few years earlier, in September 1905. Her name was Amelia Hatch and she lived in Ower, near Romsey. At the time she was a nonagenarian and had seven children, sixty-five grandchildren and 103 great-grand-

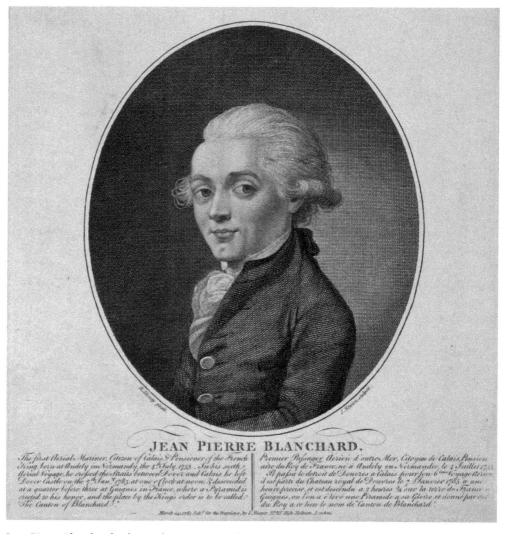

Jean-Pierre Blanchard, who paid an unexpected visit to the town.

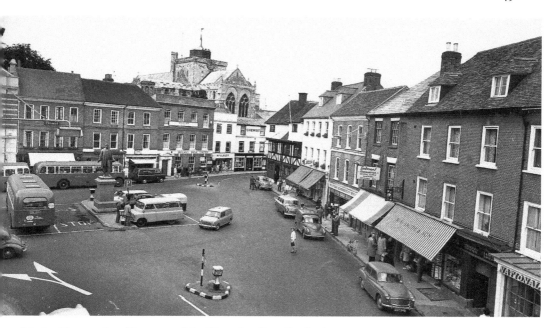

Market Place, 1960s. (Courtesy of the Viney family collection)

children, making 175 descendants in total and space around the table at Christmas undoubtedly somewhat limited!

Another name you almost certainly won't recognise – this book is called *Secret Romsey* for a reason – is that of Jean-Pierre Blanchard, an eighteenth-century French inventor best remembered nowadays as a pioneer of balloon flight. He would later become the first man to cross the Channel by air. He made his first successful balloon flight in Paris in March 1784 and moved to London that August. On 16 October that year he made another flight from the military academy in Chelsea, which landed in Sunbury-on-Thames. He took off again and this time landed in Romsey, landing in Lord Palmerston's park. A magazine at the time recorded:

> M Blanchard pursued his aerial voyage to Romsey where he descended at exactly half-past four in the afternoon...Still standing in his balloon M Blanchard was carried through Lord Palmerston's park into the middle of the Market Place amid the acclamation of a great concourse of people, having seen, as they thought, an extraordinary kite flying in the air.

At the time Lord Palmerston owned Broadlands and it's in excess of a quarter of a mile from even the outer edges of the Broadlands Estate to the marketplace.

Perhaps slightly better known, by historians anyway, is Florence Nightingale. She was born on 12 May 1820 and is generally thought of as the founder of modern nursing. She was born into a rich upper-class family. When they moved back to England the following year they purchased two homes, one in Derbyshire and one at Embley Park, just outside

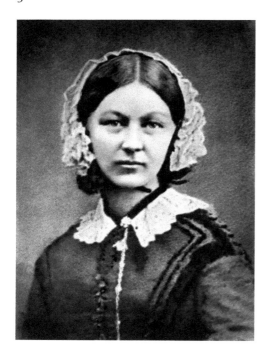

Florence Nightingale.

of Romsey. She is said to have had her calling from God while being sat under a giant cedar tree in the grounds of Embley Park on 7 February 1837. In 1854, she and a staff of fellow nurses were sent to the Ottoman Empire during the Crimean War, and it was when her reports about the horrific conditions for the wounded got back to Britain that her reputation was made. After the war she was incredibly productive in writing, training nurses and pioneering social reform and hospital planning. She died on 13 August 1910 and her body was brought by train from Waterloo station to Romsey and the funeral procession went to the graveyard at St Margaret's Church in East Wellow, just outside of Romsey, where she is buried.

Another historic notable from the area is Lord Palmerston, a nineteenth-century British prime minister. Henry John Temple, to give him his birth name, was the 3rd Viscount Palmerston, the son of Henry Temple, the 2nd Viscount Palmerston, who himself was the son of – you guessed it – Henry Temple, the 1st Viscount Palmerston. There seems to be some dispute over the location of his birth, as many of the early biographies and certainly the multitude of press reports covering his death and funeral suggest he was born at Broadlands in Romsey; however, other sources, including the British government website, suggest he was born at the family home in Westminster. Given that Lord Palmerston himself indicated his birthplace as Broadlands in the 1861 census, and this is a book about Romsey, we'll opt for the local option. What all these reports agree on is that he was born on 20 October 1784.

Educated at Harrow and at Cambridge, he succeeded to the Irish peerage on the death of his father when he was just eighteen. In 1807 he became an MP, representing Newport on the Isle of Wight; during his lifetime he would also serve as MP for Cambridge

The Daily Mirror

THE MORNING JOURNAL WITH THE SECOND LARGEST NET SALE

No. 2,128. MONDAY, AUGUST 22, 1910 One Halfpenny.

FLORENCE NIGHTINGALE LAID TO REST IN A WILTSHIRE VILLAGE: CRIMEAN VETERAN'S LAST TRIBUTE TO THE "LADY WITH THE LAMP."

Front page of the *Daily Mirror* commemorating the death of Florence Nightingale.

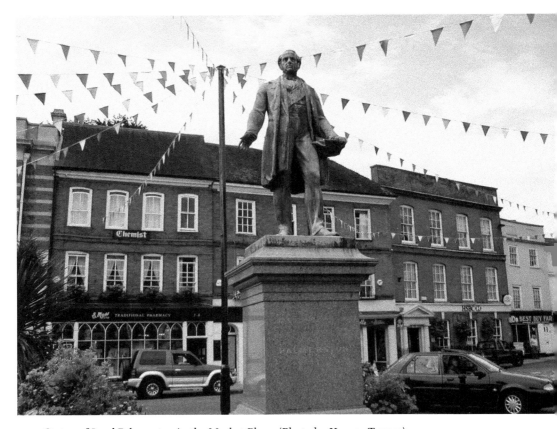

Statue of Lord Palmerston in the Market Place. (Photo by Harvey Turner)

University, Bletchingley, Hampshire South and Tiverton. In 1809, the then Prime Minister Spencer Perceval offered him the post of Chancellor of the Exchequer, but Palmerston himself thought he was too young for the job and accepted the position of Secretary at War. He would hold this job for twenty years.

Traditionally a Tory, in 1830 he joined Lord Grey and the Whig government, becoming Secretary of State for Foreign Affairs. Although Palmerston had the support of much of Parliament, he was strongly disliked by Queen Victoria as his view that the government's foreign policy should focus on increasing Britain's power in the world conflicted with her views that the government should preserve existing royal families against republicanism.

He became prime minister in 1855 at the age of seventy and again in 1859 when he was seventy-five.

He died on 18 October 1865 while still in office. He left directions that his remains should be interred without pomp or circumstance in Romsey Abbey, but the queen intervened and he was buried in Westminster Abbey. His widow was somewhat peeved by this, but ultimately she was buried alongside her husband. A special train was commissioned so that everyone from Romsey could attend the funeral if they wanted to; twenty-one estate tenants and servants, sixty Romsey Volunteers, members of the council and a number of other people all made the journey and took part in the ceremony.

Aloof Lord Palmerston
looks down
Upon the ceaseless
traffic in the town.
Inscrutable as the
Egyptian Sphynx
I sometimes wonder
what he really thinks.

William Waller

The pavement in the Market Place. (Photo by Harvey Turner)

A bronze statue of Palmerston in the marketplace and a stained-glass window in the abbey (near the tomb of the Temple family) were unveiled in July 1868. They had originally planned to install a mortuary chapel at the eastern end of the abbey in his memory, but this was abandoned due to cost.

DID YOU KNOW?
In the late seventeenth century, Romsey innkeeper William Ives was murdered by his wife, Esther, and her lover, John Noyse. They were caught literally red-handed, with Ives' blood all over their hands and tried for murder at Winchester. They were executed in the Market Place. John Noyse was hanged, 'fuming to the spectators ... warning them ... against profaning the Sabbath, drunkenness and keeping company with women in a lascivious and unlawful manner.' Esther, meanwhile, was sentenced to death by burning but the executioner strangled her before the flames took hold.

THE
ECONOMIC WRITINGS

OF

Sir WILLIAM PETTY

TOGETHER WITH THE

OBSERVATIONS UPON
THE BILLS OF MORTALITY

MORE PROBABLY BY

CAPTAIN JOHN GRAUNT

EDITED BY

CHARLES HENRY HULL, Ph.D.
CORNELL UNIVERSITY

VOL. I

CAMBRIDGE
AT THE UNIVERSITY PRESS
1899

One of many publications by Sir William Petty.

Sir William Petty was a seventeenth-century English economist, scientist and philosopher who was born in Church Street, Romsey. He was born in May 1623, the son of Anthony Petty, a clothier, and was a precocious and intelligent youngster. After a period in the navy he left to study anatomy in Holland, but returned to England in 1646 and studied medicine at Oxford University. In 1652, he left on a leave of absence and travelled with Oliver Cromwell's army in Ireland as a physician. With a wide range of interests he was able to secure a contract for charting Ireland in 1654, enabling those who lent funds to Cromwell's army to be repaid with land.

Back in England he successfully ran for Parliament and was elected a MP for West Looe in Cornwall in January 1658. This Parliament, called by Richard Cromwell, was dissolved shortly afterwards and Petty went back to Ireland. He returned to England at the Restoration and was presented to Charles II, being knighted by him on 11 April 1661.

He was one of the earliest members of the Royal Society and was nominated on its first council. His studies and work was aimed more at science and political economy rather than physic, which he effectively gave up when he returned from Ireland.

He died of gangrene of the foot on 16 December 1687 aged sixty-five and is buried in Romsey Abbey.

Sir John Russell Reynolds was a neurologist and physician who was born in Romsey in May 1828. He was educated mainly by his father before he went to study medicine at University College in London. He was considered a brilliant student and graduated in 1851 as a university scholar and gold medallist in physiology, comparative anatomy and medicine. He held the presidencies of the Royal College of Physicians and the British Medical Association and was made physician to the royal household in 1879. He was best known for his early writings on nervous diseases and was one of the first to suggest the possibilities of electricity as a therapeutic agent. He edited the *System of Medicine*, which was published in five volumes between 1866 and 1879.

While we're on the subjects of noblemen, let's take another step up the scale. Baron Greenway of Stanbridge Earls passed away in December 1934. He was born Charles Greenway to John and Lucy Greenway in June 1857 and was one of the founders of the Anglo-Persian Oil Company. He was raised to the peerage in 1927 and succeeded in his titles by his son Charles.

Moving on a few years, Wilbert Vere Awdry was born in June 1911 in a vicarage near Ampfield. His father, Vere, was the local vicar and had built a model railway layout in the garden of his vicarage. That might go some way to explaining young Wilbert's fascination with trains. (The unusual Christian name came from a combination of his father's favourite brothers, William and Herbert.)

Educated in Wiltshire, young Wilbert went to Oxford before being ordained as a deacon at Winchester Cathedral in 1936. He went on to become a curate at Odiham in Hampshire, then West Lavington in Wiltshire. When war broke out in 1939 Awdry declared himself a pacifist, which put him in conflict with his superiors and he was asked to leave the parish. The pacifist Bishop of Birmingham appointed him to a curacy in Kings Norton.

While there, in 1942, his first son, Christopher, was confined to bed with measles. Awdry amused him with a story about a little old engine who was sad because he hadn't been out in a while. Seizing on the first name that came to mind, the engine was called

John Russell Reynolds.

Edward and the story became *Edward's Day Out*. Wilbert's wife Margaret persuaded him to try and get it published, and after several rejections the story was published as *The Three Railway Engines* in 1945. Another book was published in March 1946. It was called *Thomas the Tank Engine*.

Further stories followed, the last being published in 1972. In 1983 his son Christopher wrote a series of thirteen further books about the engines of Sodor. He died in March 1997 and when asked how he would like to be remembered in one of his last interviews, his response was: 'I should like my epitaph to say, "He helped people see God in the ordinary things of life, and he made children laugh".'

The late broadcaster Sir David Frost brought Michelmersh Court just outside of Romsey in the late 1980s. A Grade II-listed building and former rectory, Frost and his wife would spend the week in London and retire to Michelmersh at weekends.

Born in Kent in April 1939, Frost was the son of a Methodist minister and his wife. He graduated from Cambridge University with a Third in English. He became a trainee at Associated Rediffusion and would perform at the Blue Angel nightclub at Berkley Square during the evenings. He rose to prominence when he was chosen to host the satirical programme *That Was The Week That Was* in 1962. After that show and its successor, *Not So Much a Programme, More a Way of Life*, he started an interview-based show called *The Frost Programme*.

He was involved in the launch of London Weekend Television, an ITV contractor, and would later be one of the infamous 'Famous Five' who launched ITV's breakfast TV service *TV-AM* in the 1980s.

In the late 1960s he had his own show on American television, which would subsequently lead to his famous interviews with former US President Richard Nixon. Having been in television for forty years, in 2006 *The Sunday Times* estimated Frost's worth to be in the region of £200 million.

Set in 21 acres of woodland, Michelmersh Court has nine bedrooms, a secluded outdoor swimming pool and a tennis court. Frost was known to entertain the likes of Stephen Fry, Lord Lloyd Webber, George Bush Snr and Baroness Thatcher there. They put the house on the market in March 2013, a few months before his death.

Roger Waters, singer and guitarist known primarily for his work with the group Pink Floyd, has lived in the area for almost thirty years. A keen fisherman, he brought Kimbridge Manor, just outside of Romsey in the early 1990s. The manor and estate date back to the thirteenth century and has the River Test running through it.

Waters was born in Surrey in 1943. In 1965, while studying architecture in London, he formed Pink Floyd with Syd Barrett, Nick Mason and Richard Wright. When Barrett left in 1968 he became their co-lead vocalist, lyricist and conceptual leader. Floyd's profile could be said to have peaked with the 1979 double album *The Wall*, which was written entirely almost by Waters and is largely based on his life story. The album has sold over 23 million copies in the USA and is said to be one of the top three best-selling albums of all time.

One of the more well-known contemporary residents is Charlie Dimmock, a gardening expert and TV presenter. Brought up in the area – she attended Wellow Primary School and Mountbatten Secondary School – her public profile grew in the late 1990s when she

Alma Road. (Photo by Nick Chivers)

joined the BBC gardening series *Ground Force*. Since then she's appeared on numerous shows, written several books and been involved in many charity works.

Retired English football coach Lawrie McMenemy lives in the outskirts of Romsey. McMenemy, born in July 1936, is best known for his spell as manager of Southampton Football Club and is rated by the Guinness Book of Records as one of the twenty most-successful managers in post-war English football.

He started his football career as a player, but in 1961 an injury ended his career and he moved into coaching and management. In 1964, he was appointed manager of Bishop Auckland and took them from a struggling club to Northern League champions. Spells at Sheffield Wednesday, Doncaster Rovers and Grimsby Town followed before he was hired by Southampton Football Club as assistant manager, being promoted to manager just four months later in November 1973.

In 1976, McMenemy guided Southampton, then in the second division, to victory in the FA Cup final over first division Manchester United. Two years later McMenemy took Southampton to the first division and the following year they reached the League Cup final.

But it isn't just people with a high national, or international, profile. Romsey has inspired its own set of unique characters and heroes. Dr Peter Johnson was a local GP, based at the Alma Road surgery, like his father before him. During the Second World War he served in

the Army Medical Corps and when he returned to the town in 1947 he offered his services to the local Scout troop. They needed a district commissioner and he accepted the role, rebuilding and developing scouting in the district after the ravages of war. He remained district commissioner for eighteen years, but in 1965 he changed role and became district chairman, taking a higher view and overseeing all Scouting within the district. He continued in that role for an astonishing twenty four years and in 1988 became district vice-president, a role he continued until his death in 2002. If that CV wasn't enough to show how much Scouting meant to him, there are stories that he would deliver babies while in his Scout uniform and if it happened to be bob-a-job week, he'd charge the new mother a shilling afterwards.

Some people, though, only had a passing acquaintance with the area. Film director and producer Guy Ritchie, known for films such as *Sherlock Holmes* (2009) and *The Man from U.N.C.L.E.* (2015) was born in Hatfield, Hertfordshire. He was educated for a short while at Stanbridge Earls School, just outside of Romsey. He was expelled at the age of fifteen – according to him because of his drug use; according to his father because he would cut class and entertain a young lady in his room. Guess he hasn't done too badly since...

Also paying a flying visit was actress and Princess of Monaco, Grace Kelly, who paid a private visit to Earl Mountbatten and his family at Broadlands in June 1963. A photo opportunity occurred when she went to visit St Joseph's Roman Catholic Church.

6. Secret Buildings

A building can be listed when it is of special architectural or historical interest and considered to be of national importance and worth protecting. There are estimated to be over half a million listed buildings in the United Kingdom, with 92 per cent of them being Grade II listed – over 180 of them can be found in Romsey and the surrounding villages.

Of course, this doesn't compete with the likes of London, which has significantly more listed buildings, but it's not a bad statistic for a small town and examination of some of them, and their origins, provides a colourful picture of the town.

DID YOU KNOW?
The Melchet Court Estate in Sherfield English, near Romsey, was the former home of Lord Melchett, the head of Imperial Chemical Industries, who died in December 1931. The property covered some 1,719 acres and was sold at auction for £29,500 in 1935. At the time the mansion, which was originally built in 1863, included a 'Venetian saloon, library, indoor squash court, 15 principal bed and dressing rooms, 6 guest bedrooms, nursery wing, 14 servants bedrooms and 12 bathrooms'.

King John's House

One of those listed buildings is popularly known as King John's House. However, King John never actually lived there as it was built in 1256 – forty years after he died. John was King of England from April 1199 until his death in 1216 and it's known that he hunted extensively and had a hunting lodge built in Romsey. The current King John's House is just over the road from the abbey and the royals have always maintained close links with the church so it's not inconceivable that such a lodge would be in close proximity to it. Plus, the King John building is attached to a late Tudor/early Jacobean cottage. Close study of some of the beams used in the building show that they had been reused for the building that was constructed in 1256, suggesting that perhaps there was a preceding property built on the site for King John. It's now an accredited museum that contains a number of exhibitions and holds numerous historical talks, art exhibitions, craft events and school trips.

Broadlands

Of course, perhaps the highest profile listed building in the area is Broadlands, current residence of the Earl and Countess Mountbatten of Burma. The formal gardens and

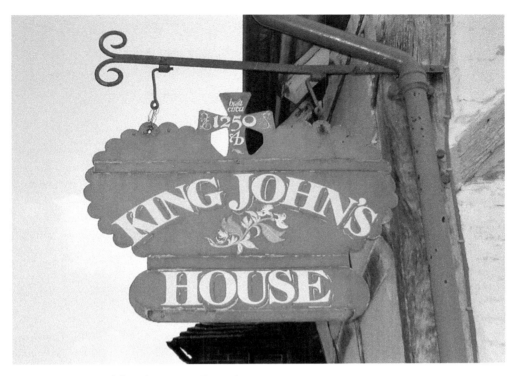

King John's House. (Photo by Harvey Turner)

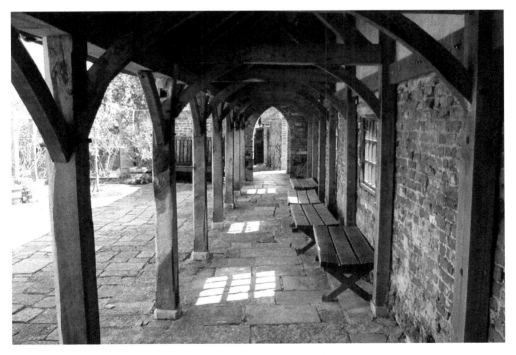

Garden seating at King John's House. (Photo by Harvey Turner)

The garden at King John's House. (Photo by Harvey Turner)

DONATION FOR THE GARDEN

King John's House relies on volunteers. (Photo by Harvey Turner)

Hurlsey Hunt in the Market Place on Boxing Day. (Courtesy of the Viney family collection)

historic landscape of the site are in fact Grade II* listed (making them, as the definition goes, 'of more than special interest').

Broadlands used to be owned by the abbey in the tenth century, but was surrendered to the Crown when Henry VIII disbanded monasteries, priories, convents and friaries in 1539. It was first granted to John Foster, a steward at the abbey, and then to Sir Thomas Syemour in 1544, an uncle of Edward VI. He sold it in 1547 to Sir Francis Fleming, a former Southampton MP who brought several properties in the town. He died in August 1558, leaving Broadlands to his family. His son William had a daughter Frances and when she married Edward St Barbe the Broadlands estate passed to the St Barbe family. St John Barbe, who succeeded to it in 1661, made significant improvements to the house and laid out a formal garden. When he died it was sold in 1736 to Henry Temple, 1st Viscount Palmerston. He was an Irish nobleman and from 1727–47 MP for three different boroughs in succession.

His son, 2nd Viscount Palmerston and also called Henry, commissioned Capability Brown to remodel the house and grounds. When he died in April 1802 the estate fell into the ownership of his son, the 3rd Viscount Palmerston – yes, another Henry. He was more

Lord Palmerston.

commonly known, around Romsey at least, as Lord Palmerston and served in government for forty-six years – twice as prime minister, a role he first secured when he was over the age of seventy.

On his death in 1865, Broadlands passed to his stepson William Cowper. Cowper was the Liberal MP for Hertford and served as such for thirty-three years before becoming MP for Hampshire South in 1868. In 1880 he was raised to the peerage as Baron Mount Temple. He married twice but had no children and consequently on his death in 1888 his estates were inherited by his nephew, the Rt Hon. Evelyn Ashley.

Ashley was private secretary to Lord Palmerston from 1858–65 and served as MP for Poole and the Isle of Wight. Broadlands was eventually inherited by his granddaughter, Edwina, in 1939. She married Louis Mountbatten in 1922 and the estate is now owned by their grandson and his wife. Press reports in the twenty-first century habitually point out that it's a sixty-room Palladian mansion set in 5,000 acres with a museum-sized collection of antiques, Greek and Roman marbles and old masters' works, including three Van Dykes. It is reputedly worth £100 million.

Gunville Gatehouse

This house, at the junction of Southampton Road and the Bypass Road, is an energetic stone's throw from the Broadlands estate. It was built in 1864 by the London & South Western Railway to serve as a toll house on the Southampton to Salisbury turnpike, which had been rerouted from Broadlands. Tolls on turnpike roads in the UK were abolished in 1872, after which roads were maintained by local authorities, so it had a short life as a functioning toll house before being purchased by the Broadlands estate.

Gunville Gatehouse today. (Photo by Nick Chivers)

Bell Street, 1917. (Courtesy of the Viney family collection)

Seems like the ideal place for a council meeting. (Photo by Harvey Turner)

The Old Manor House

Parts of this historic building are thought to date from the sixteenth century, with much of it dating from the early 1600s. It became part of the Broadlands estate in 1807 and for many years in the twentieth and twenty-first centuries was a restaurant run by chef Mauro Bregoli. It's now currently owned and operated by the Prezzo restaurant chain.

The Tudor Rose

Some pubs in the town predate the high points of Romsey's alcohol-based history. The Tudor Rose, in the marketplace, dates back to the fifteenth century and functioned as the town's Guildhall. It was licensed as a pub in the early 1800s and on the upper floor is a half-timbered Tudor hall of splendid quality with a stone fireplace at one end. Sadly, members of the public are not allowed up there because of fire regulations.

The Workhouse

The workhouse was a place where those unable to support themselves were offered accommodation and employment. Although they are often associated with the Victorian era, their origins – and the origins of the term – date back to the seventeenth century. No. 80 The Hundred, currently a Thai tapas restaurant, is believed to be the site of a former women's workhouse from the mid-eighteenth century.

A workhouse and infirmary was built on the main road to Winchester in 1774 behind The Sun Inn. It was enlarged in 1836 at the cost of £900 and was a small U-shaped building with males on the west side and females on the east. An 1866 report by the Poor Law inspector (a chap by the name of Mr W. H. T. Hawley) noted:

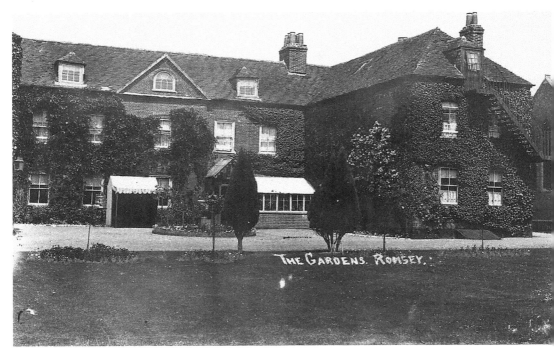

Former workhouse gardens. (Courtesy of the Viney family collection)

The site is in all respects a good one, and there is a large garden attached to the workhouse. The house is an old one, enlarged and improved and has sufficient accommodation for the inmates of all classes...The beds are stuffed with flock and straw...The men and boys wear fustian jackets and waistcoats and corduroy trousers. The women and girls gowns and upper petticoats, and all classes have a sufficient supply of warm under clothing of all sorts. The able men break stones, the aged and infirm are employed in gardening and the women in household work, washing and making and mending linen...There are two schools in the workhouse, one for the boys, the other for the girls.

In 1870, an infirmary was added on to the male side, and in 1890 a new female ward was added, with a separate female infirmary coming ten years later. Shortly after 1930 it was redesignated as a Public Assistance Institution under the control of Hampshire County Council and in 1948 it became a retirement home known as The Gardens. The main workhouse block has now been converted to flats.

Harefield House

Harefield House was a Victorian villa in its own grounds that was built at the top of Winchester Hill by the Romsey brewer Sir Thomas Strong around 1880. Sadly he committed suicide there just six years later. The house was subsequently put up for sale and the adverts show just how big the property was:

Original estate wall of Harefield House. (Photo by Nick Chivers)

Strongs Close. (Photo by Nick Chivers)

A substantially erected family residence, fitted with electric light and all modern requirements, and containing dining and drawing rooms, the latter opening into a large conservatory, library, morning and breakfast rooms, nine bedrooms, two dressing rooms, boudoir, bathroom, linen room, dairy and all necessary domestic offices; excellent stabling for six horses; coachman's and gardener's cottages, kitchen gardens with range of conservatories, vine and peach houses; brick forcing pits and other accessories with about seventeen acres of garden ground , meadow and park land, well planted with trees and shrubs. There is an entrance lodge and long carriage drive.

The building passed through several owners until, between the world wars, it was owned by a Colonel Langford, whose wife laid the foundation stone for Romsey Hospital in 1930. During the Second World War the house was requisitioned by the 210 Maintenance Unit of the RAF and then purchased by Romsey Borough Council in 1946 and converted to flats. They were knocked down in the early 1990s. The last remaining part of Harefield House was demolished in 1994 and replaced with eight flats and nineteen other dwellings in three roads named Faber Mews, Brickwoods Close and Strongs Close. Some of the original wall remains and forms the boundary of some of the gardens of Strongs Close. The buildings in Brickwoods Close have been arranged so that their outline resembles that of Harefield House.

Sadler's Mill

Sadler's Mill, sited on the outskirts of the town centre, is perhaps the best known of Romsey's surviving mills. It dates back to the sixteenth century, when it was owned by the manor of Great and Little Spursholt and belonged to Sir Raphe Sadler, an English

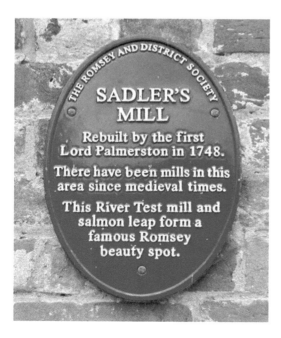

One of the few remaining mills in the area.
(Photo by Harvey Turner)

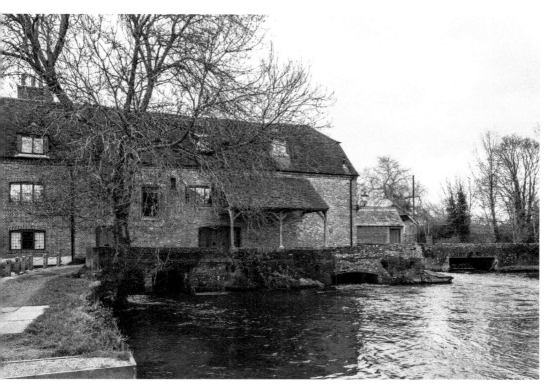

Sadler's Mill. (Photo by Nick Chivers)

statesman who served Henry VIII as Privy Councillor, Secretary of State and Ambassador to Scotland and was appointed Chancellor of the Duchy of Lancaster in May 1568. It functioned for many years as a corn and grist mail and at one stage was owned by Lord Palmerston, who rebuilt it in 1747 and thirty years later sold it a gentleman by the name of Benjamin Dawkins.

It then passed through a number of owners before being brought by the Broadlands estate in 1889. It ceased working as a mill in 1932 and Broadlands sold the building in 2003. The new owners restored the building, paying care and attention to the original structure. Carbon dating at this time established the original building to date back to around 1650.

Crosfield Hall

Crosfield Hall, a building housing the hall itself and three function rooms targeted for community activities, sports, commercial events and social functions, can be found between the Romsey Bypass and The Hundred. It is named after Sir John Joseph Crosfield, who was born in April 1866. He was the son of John Crosfield, who founded the firm Messrs Joseph Crosfield & Sons, a soap and chemical manufacturers based in Warrington. Among many other things, Crosfield & Sons acquired the patents to hydrogenation, a process used primarily in the production of vegetable oils.

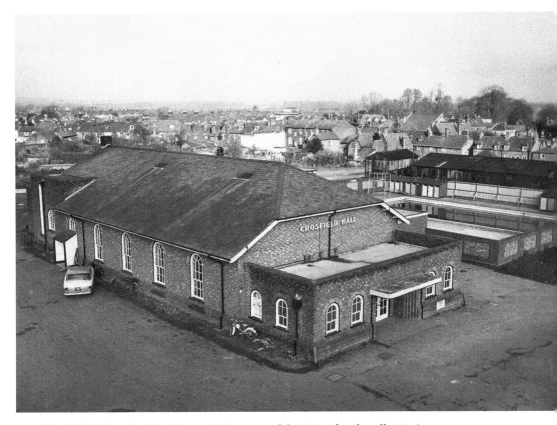

Crosfield Hall and swimming pool. (Courtesy of the Viney family collection)

John, one of nine children, was a horticulturist and garden designer. He brought the Embley estate in 1921. He and his wife Alice were great supporters of nursing and were highly thought of around the world as benefactors for numerous hospitals, nursing institutions and health centres. In 1932 a visit to Embley was held as part of a conference considering the formation of the Florence Nightingale Foundation. Delegates from thirty-two countries attended.

John was, for many years, President of the Romsey and District Hospital and served as High Sheriff of Hampshire in 1932. He died in May 1940 and is buried in St Margaret's Church, East Wellow.

The Plaza Theatre

One of the buildings that stands out as you enter Romsey from the south is the Plaza Theatre. For over thirty years it's been the home for Romsey Amateur Operatic and Dramatic Society (RAODS), owned and operated by its members.

It was built in 1931 as a cinema and from the 1930s to the 1960s it did very well, but as TV got a grip on the nation it started to lose its audience. By the 1970s it became a bingo hall, but that too failed and the building was left derelict.

RAODS bought the Plaza in 1982 for £150 000 – quite a daunting sum. Over the following two years many RAODS members put in many hours of hard work to convert it into the flourishing theatre that it is today. They debuted their first show in the refurbished building in 1984.

Embley Park

The manor of Embley belonged to Romsey Abbey in the tenth century, passing into Norman hands in 1087. John Shottere was recorded as owning it in 1431, but by the turn of the century it had passed to the Kirby family, in whose hands it remained until ownership fell to the Ashley family in the early seventeenth century due to marriage. During the eighteenth century Embley passed by marriage and in divided ownership to the Wyndham family and to John Thorpe. The two parts were reunited under the ownership of Sir William Heathcote of Hursley Park, Winchester. He and his son, Sir Thomas Freeman Heathcote, enlarged the estate, added to the house and laid out drives and gardens. Following Thomas' death in 1825 the estate was put up for sale. Newspaper adverts at the time give an idea of the scale of the estate:

> The mansion is an excellent and commodious house, pleasantly situate in the centre of the property; containing ample accommodation for a family of first respectability and in the most perfect order for immediate occupation; having attached and detached domestic and other offices of every description, spacious and truly convenient; with kitchen garden, flower garden, greenhouses etc. The whole abundantly supplied with spring and soft water. The grounds are diversified and ornamented with stately oak and other trees. The lawns and pleasure grounds abound with American and other choice plants and shrubs. The plantations have been laid out and managed with great skill and care...The carriage drives through the park and plantations are gravelled for several miles, communicating with three turnpike roads...At the several entrances are cottage lodges tastefully erected in styles suiting their position. Within the grounds are several ornamental buildings and a richly finished grotto and fountain with fish ponds and extensive lakes, supplied by streams flowing through the estate; also keepers' houses and other cottages, for the preservation of game and the protection of property.[7]

The estate was sold to William Edward Nightingale, the father of Florence Nightingale. The family made extensive alterations and enlargements to the house in 1837 and added a formal terrace at the south. It stayed in the family until the death of William's nephew in 1894 when it was once more put up for sale.

It passed through the hands of two more owners before it was sold to John Joseph Crosfield in 1921. After his death in May 1940 it was again put up for sale, being described as a 'small mansion and 1.748 acres ... The house is said to be largely panelled and appointed in oak. It has a lounge hall, five reception rooms, fourteen principal bedrooms, day and night nurseries, fourteen servant's bedrooms and five bathrooms.'

7 *Morning Chronicle*, 8 July 1825.

Road sign plus Florence Nightingale in Wellow. (Photo by Nick Chivers)

After the Second World War the estate was divided and sold, with an all-boys' school established in the house and surrounding grounds. The school became co-educational in 1990 and in 2005 merged with Atherley School to become the current Hampshire Collegiate School. Thanks to subsequent division and sale in the late twentieth century the school (a registered charity) has purchased the lease on the house, gardens and part of the adjacent park. That sale has also enabled Wellow Golf Club to build the present course, which lies both within and to the south-west of the estate.

DID YOU KNOW?
Embley Park, the former home of Florence Nightingale, was put up for auction in 1920. It was described as comprising '6 reception rooms, billiard room, 30 bed and dressing rooms and ample domestic offices, central heating, electric light and excellent water supply. Good stabling, cottages and lodges...the whole area covering 3,766 acres.' The auctioneers described it as 'an excellent, medium-sized residence'.

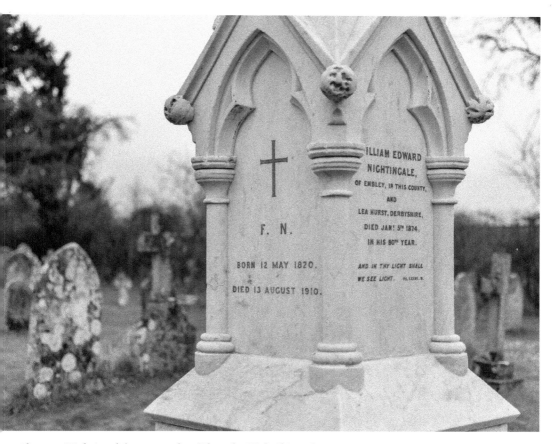

Florence Nightingale's grave today. (Photo by Nick Chivers)

The White Horse

The White Horse Hotel has a long history in the town. It's thought that the first building on the site was a guest house for the abbey in the twelfth century, and stone cellars reveal early work that was clearly renovated in Tudor times. Written records confirm there has been an inn on that site since the 1500s and some of the timber frame within is thought to date back to 1450. During the eighteenth century a new façade and upper floors were added – thirty bedrooms and stables for fifty horses made it a useful stop for visitors travelling between London and Bristol. Documents from the eighteenth and nineteenth centuries show that at one time it had a yard, stables, coach houses, granaries, a brewery, a taproom, a dovecote, gardens and a piggery. In keeping with the times, it functioned not only as an inn, tavern or any of the other words a thesaurus may offer, but also as an auction house and site for inquests.

The White Horse is currently owned by a property developer based in Birmingham (who also owns The Abbey Hotel not far from The White Horse). According to the land registry entry the hotel cannot be sold without the consent of the National Crime Agency. The White Horse is managed by a different company and is currently a four-star hotel.

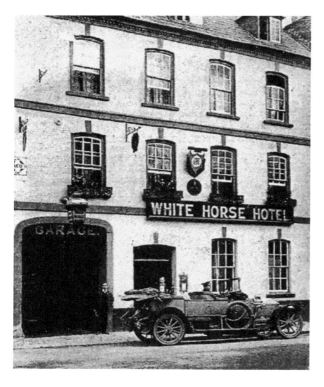

The White Horse, 1903.

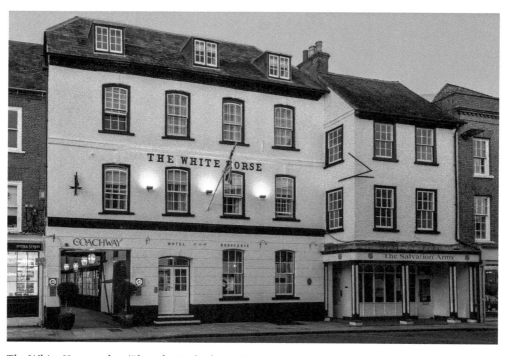

The White Horse today. (Photo by Nick Chivers)

Romsey Signal Box

Until 1982 there was a very active signal box in Romsey that controlled the railway junction and enabled passenger and freight trains running between Southampton and Salisbury, with a branch line down to Eastleigh. Resignalling works carried out by British Rail meant the box was made redundant and was due to be demolished.

The signal box and its lever frame was bought by the Romsey & District Buildings Preservation Trust, a charitable trust established in 1975 'to preserve for the benefit of the people of the Test Valley area ... whatever of the English historical, architectural and constructional heritage may exist in the area.' Over the last forty years they've rescued more than thirty buildings in Romsey and the Test Valley from demolition and restored them to useful habitation.

The box was lifted into the grounds of the adjacent infants' school and work began to restore the signalling equipment to working order. The preserved box is believed to date from around 1871 and was thus probably one of the oldest boxes still in service when it closed in the early 1980s.

The box was purchased for the sum of £10 and the trust also agreed to fund the £1,000 removal costs. On the night of Sunday 26 June 1983 the wooden first floor, weighing around a tonne, was lifted across the tracks to a temporary position in the school grounds. The twenty-three-lever frame, weighing around 3 tonnes, was then lifted over. A new ground floor was constructed on a piece of land bought from Hampshire County Council and in April 1987 the frame was fitted onto the new base, closely followed by the first floor.

The signal box is open to the public during the afternoons of the first Sunday of every month, excluding January, and the third Saturday of every month, excluding December.

Landing in Romsey

Although this chapter focuses on buildings, it's worth mentioning that there are – and have been – a number of airstrips in the Romsey area.

In April 1910 the *Romsey Advertiser* noted:

Mr Rowland Moon, a Southampton Aeroplanist, made a proving flight in his aeroplane 'Moonbeam' from the paddock behind Paultons House. During an attempt to take-off, after about two hundred yards with the aeroplane four feet above the ground, there was a sudden gust of wind and the tail was caught in branches of a tree. The plane was listed down and the only repairs required were new wheels.

He later went on to fly from a site at North Stoneham Farm, now better known as Eastleigh airfield.

There is a private grass airstrip at Pauncefoot Farm, which stretches from Gardeners Lane to the A3090. It is used for visitors to the Romsey Show and other events at Broadlands.

There's also an airstrip at Farley Farm, Braishfield, which also has a highly regarded maintenance facility as well as, apparently, various aircraft parked in various states – some airworthy, some not.

Romsey Town FC

And while it's not strictly speaking a building, it's worth mentioning Romsey Town Football Club. They were formed in 1886 when there was a meeting at the Town Hall 'to consider the desirability of forming a football club in the town'. They initially played at a site in Alma Road. They met with some success in the 1920s, winning the Hampshire Intermediate Cup and the Southampton Senior League. In 1930 they moved to a site in Priestlands (now currently occupied by Romsey School) and in 1956 moved to their current home at the Bypass Ground.

DID YOU KNOW?

In 1885 there was a funeral in Romsey, but this one was a little different: as they approached the cemetery there was a knocking from inside the coffin. They dropped the coffin, whereupon it broke and out stepped the 'dead' person inside: Martha Southwell, an inmate of the workhouse. She walked back to the workhouse, very indignant, and resumed her work in the garden and ended up using the coffin lid as an ironing board. She eventually died – for sure – in April 1935.

7. Secret Industry

Mills

The River Test and associated waterways have helped Romsey survive throughout the years. A plethora of mills around the area provided work, whether as flax mills, corn mills, paper mills or sawmills.

Indeed, the origin of mills in Romsey can be traced back to the Domesday Book, which recorded three mills in the area. In 1428, the abbess gave William Berill permission to build a new mill in the watercourse called Chaby (now known as Chavy Water), charging a yearly rent of 4s at Michaelmas and Easter. He also had the keep the mill in good condition and was not allowed to fish unless he had a license. In 1545, two water mills, called Town Mills and Mead and Malt Mills, along with a fishery formerly belonging to the dissolved abbey were granted to Thomas Thoroughgood and John Foster.

The first reported mention of a flax mill in Romsey came in the *Hampshire Chronicle* of 4 November 1822, which reported that a young fourteen-year-old girl called Fielder had become entangled in the machinery and died. Tax records show that a William

Middlebridge. (Photo by Nick Chivers)

Lintott owned Abbey Mills in 1813 and by 1823 there was a flax mill on the site there. Parliamentary returns in 1838 show that the flax mill at Romsey had a waterwheel of 16 horse power and employed thirty-one people, half of them being between the age of thirteen and eighteen.

DID YOU KNOW?
Reports on trading conditions at Romsey market were a regular feature of the financial pages in national newspapers during the middle of the nineteenth century. Aside from detailing the prices of wheat, barley, oats, beans and peas reports would also advise: 'There was a good attendance of farmers and corn-dealers at market and business was tolerably brisk: there was scarcely any difference from the last two or three weeks quotations but many bought today at prices which a week or two ago they would not give; it was evident therefore, at the close of the market, that business was in favour of the sellers.'

Holman Drive. (Photo by Nick Chivers)

By 1864 the flax mill was still working, but it changed hands a year later. By 1867 the local corn mill had closed and new building built on the site, which was being used as a classroom. The flax mill reopened as a corn mill, but by 1892 the whole site was taken over by the Sisters of La Sagesse, who remain there to this day. The corn mill was destroyed by fire in 1925 and replaced by a single-storey building three years later.

The earliest known reference to a paper maker in Romsey relates to Math plyer of Romsey Infra, a paper maker who was apprenticed to Robert Newlands of the same place in 1715. There are also references to a John Hockley, a paper maker of Romsey who was married in 1733. According to the Romsey Poor Law Assessments of 1745–62 he was rated for a paper mill that was near the abbey. The excise letter of 1816 records three paper mills as being in Romsey – one of which was the Abbey Mill – but by 1851 the town was left with just one mill.

Another paper mill was recorded as being at Test Mill, to the north-west of the abbey and, unsurprisingly, remarkably close to the River Test. It can be traced back to 1708 where the reference for it notes that it contained 'one small water wheel for 'tucking', a provincial term for fulling, and used in the manufacture of 'shalloons', a kind of woollen fabric. Throughout much of the nineteenth century it was in use as a paper mill, but has now been replaced by residential accommodation on Hollman Drive called, appropriately, Test Mill.

Boatbuilding

Perhaps one of the more unusual, or perhaps unexpected, industries that could be found in Romsey was boatbuilding.

Edward Lyon Berthon was born in Finsbury Square, London, in February 1813, the descendant of French nobility – his great-great-grandfather, St Pol le Berthon, was the only son of the Hugenot Marquis de Chatelleraut, who survived the massacre following the revocation of the Edict of Nantes. Young Edward studied medicine in Liverpool and Dublin but when he got married in 1834 he gave up his medical ambitions and travelled for a few years. Always interested in mechanical science, he started dabbling, but his ambitions took a knock when his proposal for a two-bladed propeller for boats was ridiculed when submitted to the British Admiralty. Francis Smith brought out a more successful version in 1838.

In 1841, Berthon entered Magdalene College in Cambridge to study for the Church and was ordained in 1845. After a curacy at Lymington and a living at Fareham (where the clergyman is guaranteed an income and home for his lifetime), he took up a living in Romsey and was appointed to the vicarage in April 1860. In 1877 he started the Berthon Boat Company, building folding lifeboats and other floating machines. The adverts illustrate his interesting design:

The framework of the Berthon Boat is composed of the finest Canadian Elm, with outer and inner coverings of specially prepared canvas. The action of expanding the Boat fills the space between the outer and inner coverings with air, rendering the same a perfect lifeboat. It collapses or folds up lengthways and can be stowed away in a space a few inches wide. One person can get the Berthon Boat ready for use in a minute.[8]

[8] *The Star*, Guernsey, 1 May 1879.

After the *Titanic* disaster, Berthon supplied twenty-four boats for use on the sister ship, the *Olympic*.

The Berthon Boat Works, one of the town's largest employers in the early twentieth century, was to be found in Portersbridge Street. It was a good employer. The Revd Berthon would often provide a 'most excellent repast' for his staff, with one report noting that he and his family fed upwards of forty-five staff in 1884. Some years later the staff were treated to an annual holiday, with some going for a ride through the New Forest and others going to London. The works even had their own football team.

It wasn't just boats he designed, other inventions include the Berthon Portable Hospital (which cost £55 in 1896) and a collapsible bandstand.

The reverend quit his living in Romsey in 1891, after more than thirty years in the town. Commentators at the time thought this was due to his failing health. He died in 1899 and the company continued under the guidance of his son, Edward. Harry and Frank May bought the company in 1917 and the Lymington Shipyard the following year. The two were merged in 1919 and completely relocated onto the Lymington site, where they are still going today.

He had a marvellous effect on the town, whether from his work at the abbey and his determination to restore it, or from his position as one of the town's biggest employers for a while, so it seems fitting to illustrate how he was viewed by his peers at the time. This description is from a November 1899 edition of *The Engineer*:

Mr Berthon was a very finished gentleman of the old school, courteous and refined, full of fun to the last; a very ready and eloquent public speaker. He was the intimate friend of many of the leading politicians of the day, yet he took no part in politics. In private conversation he was delightful and he possessed the very rare faculty of being an admirable listener.

DID YOU KNOW?
Wools Farm, situated around a mile from Romsey and 'consisting of a farmhouse with buildings and 116 acres of extremely good land' was available 'at a very improveable rent' of £85 per annum in 1792.

The Footners

Any book on Romsey has to mention the Footner name. While it qualifies for a number of chapters in this present volume, it's worth mentioning here because of its history.

The Footner family name has a long history with the Romsey area, with records showing it easily dates back to the mid-eighteenth century, and in all probability long before. It is two branches of the family that have been rather prominent in Romsey's history.

William Footner, born 1766, worked for many years as an insurance agent before establishing a bank in Romsey in 1807, with his son, William Andrews Footner. (As an aside, the Footner family present an interesting challenge to historians, for William Snr married Charlotte. They had six children, five girls and one boy. The boy was called William and one of the girls was called ... Charlotte). William Footner & Son was based at No. 10 The Hundred. Interestingly, a number of trade journals from the time describe the company as 'Bankers, Malsters and Wine Merchants', suggesting an interesting product portfolio – malsters are someone who malts barley to flavour beer.

William Snr died in the early nineteenth century. Following the death of his son in 1873 the bank was sold to the Wilts & Dorset Banking Company. A remnant from the bank remains: one side of their former residence (currently a well-known high street chemist) is a brick façade with a bricked-up door arch and the word 'Bank' above it.

At the age of just twenty-two, in 1823 George Bright Footner established himself in the town as a solicitor. He and his wife Jane had twelve children – six boys and six girls. His son George Maughan Footner, born around 1833, would take over the family firm on the death of his father. Their youngest son, John Bulkley Footner, born in Romsey in September 1852, would become a fellow of the Royal College of Surgeons. One grandson, Arthur Henry Footner, served with the Ceylon Contingent in Egypt and in the Suez Canal. He also took part in the original landing on Gallipoli in April 1915 and was killed while leading his men in an assault on a Turkish trench near Cape Helles on 6 August 1915. There is a marble plaque commemorating him in a side aisle of Romsey Abbey.

Foster Lake Footner, born in 1882, was the eldest son of George Maughan Footner. He would also go in to the family business but this was alongside a significant career in the military; he served as a Major in the 4th Battalion Hampshire Regiment and was awarded the DSO in the First World War. He was wounded in late 1915 and taken prisoner at Kut-el Amara at the end of April 1916.

He served as Mayor of Romsey in 1921, 1929 and 1930. He died on Saturday 18 April 1953. Footner Close, on the Woodley Estate, which was built in the 1960s, is named after him.

8. Secret Roads

Romsey has always been very respectful of its history, and the origin of road names within the town can provide an interesting and unusual insight into its past.

The Hundred

The Hundred is the main commercial thoroughfare that runs west–east through the centre of the town. From the late Saxon period – around the tenth or eleventh century – through to the nineteenth century most of the counties of England were divided into

The Hundred. (Photos by Nick Chivers)

administrative areas called hundreds. With the central part of the town originally under the bailiwick of the abbey, the land beyond that central area fell into either King's Somborne hundred or Redbridge hundred. The dividing line was the Holbrook stream, which runs near the Market Place: to the west of that you were in Romsey; to the east you were in the hundred.

The Hundred, mid-1960s. (Courtesy of the Viney family collection)

Stirling Walk, just off The Hundred. (Photo by Nick Chivers)

Pauncefoot Hill

Pauncefoot Hill is one of the main arteries in and out of the town. It was named for Bernard Pancevolt, one of the Norman followers of William I. William had rewarded the loyalty of his army with gifts of land, and gave the land around Pauncefoot Hill and Embley to Pancevolt. The land stayed in his family for over 400 years until the last male heir died in 1493.

Abbess Close

Abbess Close is a handful of houses on the relatively new Abbotswood development that was clearly inspired by the position of abbess, who for many years was in charge of the abbey and the major ruler of the town – whether it be King Alfred's granddaughter Aelflaeda, an abbess in the tenth century, Christina, a Saxon princess who filled the role in the following century, or any of the others.

DID YOU KNOW?
Hodinott Close is one of the new roads in the Abbotswood development. It was named after Ernest Hoddinott, a member of Romsey Extra Parish Council for fifty-five years – between 1895 and 1949. Except, as the sharp-eyed reader may have noticed, Test Valley Borough Council forgot one of the 'd's in the councillor's surname when it came to formally naming the road.

Wadham Close

Also on the Abbotswood development is Wadham Close, named for Jane Wadham, a cousin of Jane Seymour (Henry VIII's third wife). Jane Wadham was a nun at the abbey at the time it was dissolved (1538). She had an affair with John Foster, a steward there, causing great scandal. She defended the union on the grounds that she had become a nun against her will and that the 'malevolent persons' who forced her to do so were said to have ignored her protest and induced Foster to become a priest, thus invalidating the marriage. By 1536 Foster was indeed a priest, but when the abbey was dissolved in 1539 it allowed her to marry Foster. Foster's eventful private life gave rise to a short jingle:

> Mr Foster of Baddesley was a good man
> Before the marriage of priests began.
> For he was the first that married a nun
> For which he begat a very rude son.

St Barbe Close is a handful of houses in the Tadburn area of the town and was named for the St Barbe family, who owned Broadlands for over a hundred years in the sixteenth and seventeenth centuries. The St Barbes actually came in to England at the time of the Norman Conquest but their presence in the area came by way of Edward St Barbe, Sheriff

of Somersetshire in 1589. He married Frances Fleming, the daughter and heir of William Fleming, the then owner of Broadlands. The Broadlands estate left the St Barbe family in 1723 when Sir John St Barbe passed away leaving no children and appointing his great-great-nephew Humphrey Syndeham as his sole heir and executor.

Petty Close

Petty Close is also in the Tadburn area. This slightly large collection of houses was named for the seventeenth-century economist, scientist and philosopher Sir William Petty, who was born in the town and, sixty-four years later, was buried in the abbey. He was a contemporary and friend of Samuel Pepys and was a founder member of the Royal Society.

Latham Road

Latham Road, just off Winchester Hill, was named for Dr John Latham, a London-born medical man who retired from practice aged fifty-six in 1796 and came down to Romsey to live near his son. He became mayor of the town and is generally credited as being the town's first local historian. He died at the age of ninety-six and is buried in Romsey Abbey.

Duttons Road

Duttons Road is named after the Rt Hon. Ralph Dutton, Conservative MP for Hampshire South from 1857 until 1865. He had received the estate of Timsbury from his father, Lord Sherborne, and in the late 1840s built Timsbury Manor House on the site of Timsbury Manor Farm. Duttons Road, which connects the town centre to Greatbridge Road and thus through to Timsbury, wasn't just named after him but was constructed to ease his journey home.

Duttons Road. (Photo by Nick Chivers)

Robert Whitworth Drive. (Photo by Nick Chivers)

Robert Whitworth Drive

As roads go, though, Robert Whitworth Drive is perhaps one of the more unusual as it has no houses on it. It is, however, the main road through the Fishlake Meadows development in the town, meaning that there are plenty of houses that back on to the road and can be accessed from the road. Robert Whitworth was the main architect of the Andover & Redbridge Canal, which ran for 22 miles from Andover to Redbridge by way of Stockbridge and Romsey. Whitworth carried out the first survey for the canal in 1770, but despite an application to Parliament the following year for permission to put forward a bill, it was in 1788 when the project was successfully revived. The canal was eventually completed in 1794 at a cost of £48,000. But the canal was never busy enough to allow the canal company to make a profit – by 1827 they were eight years behind in their interest payments – and the canal finally closed on 19 September 1859.

Some roads were named after more recent citizens:

Viney Avenue

Viney Avenue is a development at the top of Winchester Hill that was built in the 1960s. The Viney family have left a strong imprint on generations of the town: Tom Viney was a long standing shopkeeper and became Mayor of Romsey in 1967. For over twenty years

The entrance to Viney Avenue. (Photo by Nick Chivers)

he was also Lord Mountbatten's official photographer at his Hampshire home. Terry Viney, his son, worked for the local newspaper the *Romsey Advertiser* for forty-one years, the last fourteen of which were as editor. He passed away in 2007.

Chambers Avenue

This comprises of eighty-four two-storey, three-bed semi-detached houses and was built in the late 1940s. The road is named after Robert Charles Chambers, who came to Romsey in 1924 as general manager of Strongs Brewery. He was also the mayor of the town from 1937 for seven years, as well as in 1952 and 1953, and became managing director of Strongs in 1954. He died in 1956.

Wills Way

Another local businessman was Arthur Wills. He owned a nursery business that was established in Romsey in 1926, with tomatoes being the main crop. The business itself was situated in the Tadburn area and was thought to be the largest nursery in the south of England. In 1926, he built twenty-four houses for his employees in Tadburn Road, with further dwellings being added over the years. As the residential area in Tadburn grew and the nursery became a memory it made sense that one of the roads in the area – Wills Way – be named after the man who had brought so much to the town.

Chambers Avenue. (Photo by Nick Chivers)

Symes Road

In the late 1940s the return of many servicemen from the war combined with the baby boom meant there was something of a housing crisis. Twenty emergency prefabricated houses were built on farmland behind Hillside Avenue and the associated carriageway was christened Symes Road, after Reg Symes, a council member since 1931, an alderman since 1932 and mayor of the town in 1947 and 1948. The prefabs were replaced by four two-storey blocks of flats in 1971.

Other Names

Yet, roads are not just named after people. Tadburn Road is named after the stream that runs through it. The Whitenap area of Romsey, along with its close neighbour, the Luzborough area, are names found in medieval documents and are derived from Anglo-Saxon origins. Whitenap, for example, has also been throughout history known as Whytenharpe and Whythernape. The current housing estate that occupied most of Whitenap was built in the mid-1960s and it doesn't take a lot to suggest that many of the roads in this area – Pine, Maple, Sycamore, Rowan, Alder – were perhaps named after trees that used to grow in the area. One of the only exceptions to this is Northlands Road, one of the routes into the estate, which was originally a collection of twelve bungalows built in 1936 and extended in the 1960s, when the rest of the estate was built.

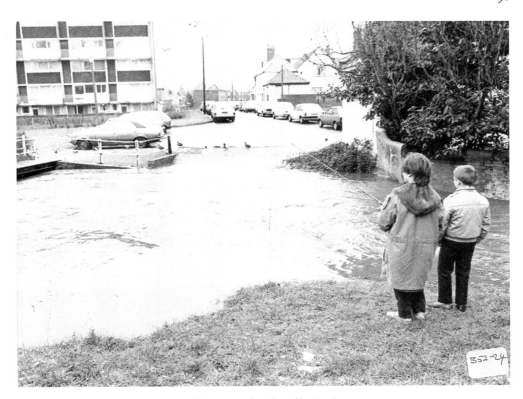

Swollen Tadburn Lake. (Courtesy of the Viney family collection)

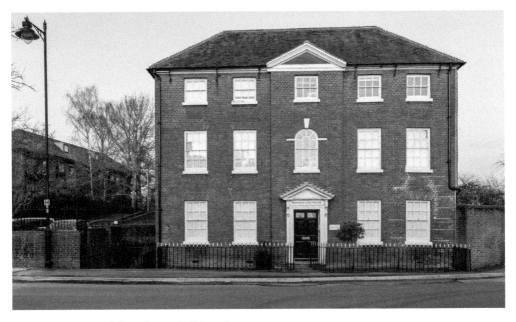

Broadwater House. (Photo by Nick Chivers)

One can only imagine why they haven't named a road after the Shitlake stream, which ran parallel to Bell Street and was so called because at one time it served as a sewer.

There are no records that indicate why Cherville Street, which connects Greatbridge Road to Church Street, is so called. Chervil, of course, is a form of herb, so it may be related to that, but what is known is that it dates back to the thirteenth century, along with other roads such as Latimer Street and Porters Lane (which would later become Portersbridge Street). In the early years of the nineteenth century there was a workhouse on the road but this was sold at auction in 1836.

In 1899, Queen Victoria's daughter, Princess Beatrice opened the Jubilee Nurses Home. It was reported as being on Cherville Street, perhaps better known as the Cottage Hospital, and was built with funds raised to celebrate Queen Victoria's Diamond Jubilee. It closed in 1932, to be replaced by the hospital on Winchester Hill, and has been converted to private houses.

Banning Street

Banning Street, once known as Bannock Street, is another of those Romsey thoroughfares whose history dates back to the thirteenth century. It was once the main way out of town to Southampton, but it's thought it fell out of favour after the dissolution in the sixteenth century when the inhabitants of Broadlands objected to the proximity of the traffic. In the 1960s, with the perpetual need for housing at one of its high points, a significant part of Banning Street disappeared, to be replaced by Broadwater Road and a number of blocks of flats.

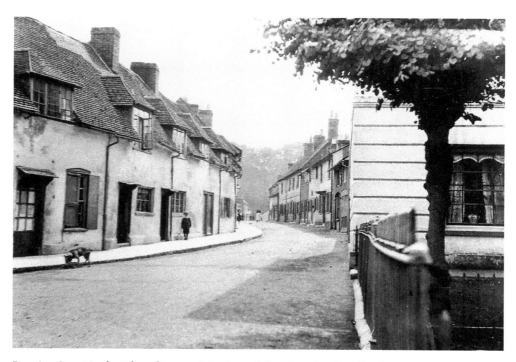

Banning Street in the Edwardian era. (Courtesy of the Viney family collection)

Church Street

It doesn't take a genius to figure out why Church Street is so called, given the proximity of the abbey. Unsurprisingly, it's another one of Romsey's roads that date back to the fourteenth century, if not earlier. Some of the many residents within the street at one time were abbey clergymen, who were not allowed to sleep within the monastic precinct but wanted to be nearby. As a result many of the buildings in the street are of a certain vintage; the Oasis shop is housed in the one-time timber-framed home of John Cox, shoemaker, Mayor of Romsey and first to sign the oath of allegiance to Charles II at the end of May 1660.

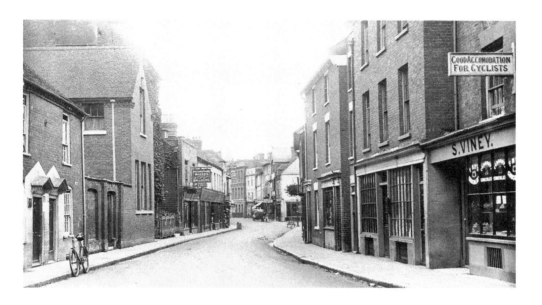

Above: A look down Church Street. (Courtesy of the Viney family collection)

Right: Also in Church Street. (Photo by Harvey Turner)

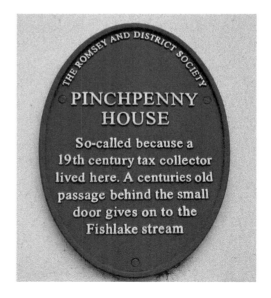

Deansfield Close

Deansfield is a small cul-de-sac of half a dozen houses at the top of Winchester Hill. It's named for a 'genteel freehold villa ... on a dry and elevated situation', which was built in the mid-1800s. When it was put up for auction in 1852 it had a sitting tenant, Revd Thomas Fison, and was described as 'approached by a carriage drive and containing double drawing-room, dining and breakfast rooms, kitchen, scullery, underground cellar and other offices, stabling and coach house, large and productive kitchen garden and pleasure grounds, the whole standing on about one acre. There is also attached to the property a servant's cottage, nearly completed.'

Duke's Mill and Mead Close

Duke's Mill is a collection of shops and residential flats to the south of The Hundred, but its history dates back to the fifteenth century when it was known as Aorn Mill and took its power from the nearby Fishlake stream. At some stage its name changed to the somewhat generic 'Town Mill' and by 1855 a J. G. Frankum was named as baker and miller. By 1911 it was used solely as a corn mill and in 1935 Jas Duke took over as miller. In 1957 mill owner Robert Ayshford Duke served as Mayor of Romsey. A fire in 1970 devastated the area and the mill was knocked down, replaced by the flats and shops that can still be found there today. However, Broadwater House, the miller's house, remains.

'Duke' isn't the only twenty-first-century road name to appear after a mayor of Romsey. Charlie Mead was known by many as 'Mr Romsey'. This nickname comes, in part, from being mayor five times between 1989 and 1997, but also from his outstanding service to the town, serving for twenty-three years as a councillor. Even in his nineties he was town councillor, a school governor, Royal British Legion branch president, a Friend of Nightingale Lodge, a trustee of Ampfield Cricket Club and a vice-president of Romsey Sea Cadets. While in office as mayor he and his wife carried out between 400 and 500 engagements annually. He died in March 2005 at the age of ninety-two. Mead Close, a collection of seventeen houses in Halterworth, was technically not named after one of Romsey's most prominent public servants, but serves as a reminder to the man and his work.

Malmesbury Road

There are over twenty roads in the UK called Malmesbury Road. Malmesbury itself is a small market town roughly 70 miles from Romsey. There are certain elements to Malmesbury's history that may sound familiar: it has an abbey that was built well over a millennium ago, as well as river – the Avon – which runs through it. And, interestingly, Athelstan, the son of King Edward the Elder – yes, that bloke who first settled some nuns in Romsey – is buried in Malmesbury Abbey.

Romsey at night. (Photo by Alex Baker)

Romsey Memorial Park at sunrise. (Photo by Nick Chivers)

Fishlake Meadows today. (Photo by Nick Chivers)

Acknowledgements

While it might be my name on the cover, books like this are rarely the work of just one person. Thanks are due to Alex Baker of Romsey-based Droid-Cam Aerial Photography, not just for the splendid aerial shots of the town but the general encouragement and information. He pointed me in the direction of Val and Colin Dawe and I appreciate their assistance and encouragement. Natasha Weyers was kind enough to let me use her lovely photo of the starling mumuration over Fishlake Meadows. She has a Facebook page (Nature Embraced Photography by Natasha Weyers) that is well worth checking out. Nick Chivers has let me use some of his stunning photos, many of which made me look at Romsey afresh. Roger Bellis delivered some marvellous stories and proved to be a source of encouragement and inspiration. Harvey Turner let me make the most of his website, for which I am eternally grateful, and Trevor Bond kindly elaborated on Freedom. Anne Viney kindly let me raid the family's photo collection and deserves eternal gratitude not so much for that, but just for being such a lovely person to talk to as well as another source of inspiration and stories. John Parker was kind enough to take the time to look through the manuscript and correct my numerous typos and ensure I verified some of my facts. Stratland Estates were a much-appreciated source of information on the Cornmarket and Matthew Dickerson was kind enough to carefully scan some of the photographs for me.

Thank you one and all! Of course, any mistakes you find in this book will be down to me and not them.